Dogs

OF THE

World

Dogs
OF THE
World

A GALLERY OF PUPS
FROM PUREBREDS TO MUTTS

LILI CHIN

TEN SPEED PRESS
California | New York

Contents

Introduction

HOW THIS BOOK CAME TO BE

Well, it all started in early 2014. That year, I found out that dog breeds have countries of origin and was so fascinated by this idea that I began to look up where each breed came from. At the same time, I set myself a design challenge to draw all these breeds using a new-to-me minimalist illustration style.

Several months of research and drawing later, my "Dogs of the World" project came alive as a series of posters showing more than three hundred stylized dog breeds organized by geographical region. That year was life- and career-changing. The posters went viral on the internet, attracting illustration and licensing clients, and connecting me with dog lovers around the world, which was the best reward of all. Owners of rare dogs were thrilled to see their pets represented, and others were excited to tell me about breeds from their country that I had missed. I learned even more *after* publishing the posters, and it has been a joy to continue discovering and drawing breeds I wasn't familiar with. In the end, my obsession became the genesis of this book, and in these pages, I've featured illustrations of as many dog breeds as I could fit, each with a few words about their history and job.

Although you can find information about a breed's appearance, size, historical occupation, and temperament on any kennel club website, and there are loads of books that provide the same content, I do something different here. Instead of making a shopping catalog of breeds, I look at the history and idea of a "breed" itself.

For instance, as I wrote this book in 2023, the Bracco Italiano had just been recognized as a new breed by the American Kennel Club. But the thing is, they are not actually new. Bracco Italianos were recognized as a breed in Europe in 2015, and dogs that resemble and do the job of the Bracco Italiano have been around in Italy for centuries. So, what does it mean for a type of dog to become

a recognized breed? And what is a breed, anyway? The answers are both fascinating and thought-provoking, and now I get to share them with you!

What Is a Dog Breed, Anyway?

Historically, a dog breed is a group of dogs with similar and predictable appearances and consistent genetics because they are related by descent through human selection, or by some degree of geographic isolation.

Usually, where the line is drawn between "breed" and "not a breed" is cultural and depends on who you ask. One modern way to identify a breed is to consider all three of the following factors in combination:

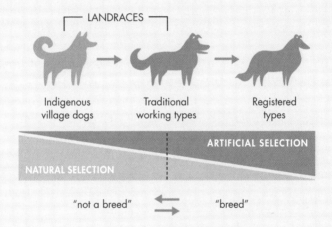

1 **Phenotype** External appearance and behavioral tendencies. Dogs of a breed are recognizable, predictable, and consistent in terms of looks, temperament, and working abilities. (Phenotype alone is not reliable enough to identify a dog's breed.)

2 **History** Place of origin and purpose. Dogs of a breed are meaningful to people in specific cultural contexts. Phenotypes and roles change over time and place.

3 **Genetic Analysis** Level of genetic similarity and distinctiveness. Dogs of a breed are members of the same gene pool. Pedigrees (documented family trees) and DNA tests are used to keep track of genetic relatedness.

I talk about how our diverse modern breeds were first created in Victorian England and elsewhere from landraces or village dogs (more on these in a bit) and have since become like dog "brands" associated with different looks, personalities, ancestral jobs, and genetic signatures. (It's worth knowing that many of these breeds are susceptible to health conditions that were created in the breeding process.) Breed populations have varieties; that is, subpopulations with different coat colors and coat types—some that are formally accepted, and others that are not. Within a breed there are often many bloodlines or lineages—these are genetically distinct subpopulations.

I also discuss landraces and village dogs, which are indigenous to different geographical regions, may have less streamlined appearances and more varieties, and are not recognized as breeds by kennel clubs. We rarely hear or read about them because their histories often aren't documented. Visually, some could be mistaken for mutts, but they are as genetically distinct as many recognized breeds!

The dogs called mutts are the most diverse and genetically varied populations in the world. They may be the accidental offspring of purebred dogs, or intentionally bred pups with carefully selected purebred parents (aka crossbred dogs). In many circles, mixed-breed or no-breed dogs are considered to be "imperfect" or less important than purebred dogs, a perception based on nineteenth- and twentieth-century myths relating to blood purity and status. Our curiosity or desire to know which breeds our mutt-looking dog may be, and the pride (or disappointment) we experience when we find out, is evidence of how emotionally invested we are in breeds. (I also look at how breed ancestry DNA tests work.)

What I hope this book brings to light is how deliberately constructed dog breeds are. What I mean by *constructed* is that the labels, categories, and histories that get attached to different breeds of dogs, as well as their physical traits and personality types, have been created or determined by groups of people (and in some cases, individuals) who want to perfect dogs in some way, to meet certain survival or emotional needs and aesthetic preferences.

In the gallery section, you will see breeds that have been created for various reasons. There are landrace varieties that have been split into separate breed identities based on simple physical traits (such as coat color or ear

shape), or based on regional or political borders. And there are reconstructed breeds—vulnerable or extinct breeds that have been re-created and preserved by crossbreeding similar types of dogs. (Many "ancient" breeds are in fact only around two hundred years old.)

Dogs do not care what breed they are, nor do they have a say in the process, but *we* do! As dog lovers or dog-curious people, we owe it to all dogs—whether they are single breed, mixed breed, purebred, or no breed—to understand where these labels come from and question what a breed designation can and can't tell us about our individual dogs. With this book, I want to celebrate the diversity of dogs in our world and inspire questions that could prepare us to be more mindful and responsible dog adopters, buyers, and guardians.

For thousands of years, dogs have fit themselves into our world and adapted to our expectations of them. Dogs deserve to have their own needs met, to feel safe, to have more agency, and to enjoy good health and happiness. Writing and illustrating this book has expanded my world and increased my love for dogs even more; I hope it does the same for you.

1

Where Dogs Come From

A BRIEF HISTORY

Around 15,000 Years Ago

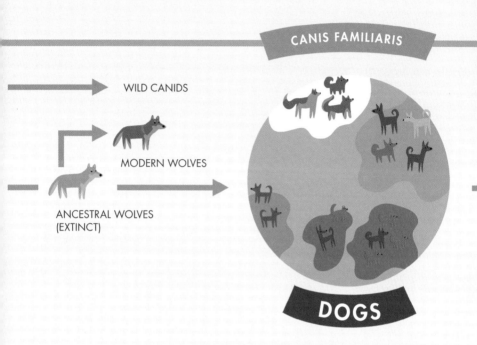

WILD CANIDS

MODERN WOLVES

ANCESTRAL WOLVES
(EXTINCT)

DOGS

Domestication Dogs evolve to become their own lineage, separate from wolves. Dogs and wolves still interbreed.

Natural Selection The first dogs are ancient village dogs adapted to different geographical regions and climates. They live around people as free-ranging animals, not pets.

Over thousands of years, dogs help people hunt for food, watch out for dangerous intruders, and manage and protect their other animals; dogs offer emotional support and companionship, too.

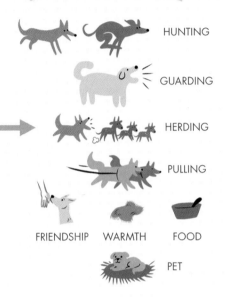

HUMAN SELECTION

HUNTING

GUARDING

HERDING

PULLING

FRIENDSHIP WARMTH FOOD

PET

LANDRACE VARIETIES

Human Selection Useful and friendly village dogs are fed and cared for, passing their genes on to the next generation. Different varieties emerge due to cultural or regional preferences; for instance, when people favor one coat color over another. (We also call these types of dogs *landraces*.)

Similar Types Although we might think of these dogs as "early breeds," the word *breed* is not used until the nineteenth century, and in a very different context.

Village Dogs and Landraces

Other Names: Regional dogs, aboriginal dogs, local dogs, native dogs, indigenous dogs, pre-breed dogs, primitive-type dogs (see page 50)

Landraces are village dogs that have adapted to a particular region and developed a common look partly due to human selection for certain traits or geographical isolation from other types of dogs. The word *landrace* comes from the German word *landrasse,* or "country breed." Landraces and village dogs existed long before breeds were intentionally created. These rural dogs are relied on around the world to hunt for food, herd, and guard animals and property. Subregional varieties with different looks and names that have evolved with people's needs and preferences often exist.

Alaskan Village Dogs in INTERIOR ALASKA were pre-Columbian sled dogs used in the development of modern **Alaskan Huskies.** Some lineages are being preserved by Native families.

St. John's Water Dogs worked with sailors in NEWFOUNDLAND. They are the ancestors of many British Retriever breeds but have been extinct since the 1980s.

Carolina Dogs (page 256)

Salish Woolly Dogs were bred for their wool by the Indigenous women of the AMERICAN PACIFIC NORTHWEST region for four thousand years. These dogs went extinct after European settler–colonialists arrived.

Amazon Heritage Dogs are indigenous village dogs that live in the forests of northeastern SOUTH AMERICA.

14

Scotch Collies are an endangered landrace and the ancestors of modern Collie breeds on the BRITISH ISLES. The TV show *Lassie* was inspired by an old-time Scotch Collie but portrayed on screen by a modern **Rough Collie**.

German Landrace Herding Dogs are still working in RURAL GERMANY. In 1899, various dogs were crossbred to create the globally popular **German Shepherd Dog** breed.

Central Asian Shepherds were used to create the **Caucasian Ovcharka** breed.

Mongolian Bankhar (page 223)

Bedouin Dogs/Village Dogs of the LEVANT are the foundation stock for the **Canaan Dog** breed.

Indian Native Dog (page 235)

Africanis (page 189)

Dingo (page 244)

Bali Heritage Dogs are the foundation stock for the **Anjing Kintamani** breed.

Taiwan Village Dogs are the foundation stock for the **Taiwan Dog** breed.

Landrace traits can disappear or change through loss of habitat and purpose—when communities are impacted by colonization, war, or urbanization; when native dogs mate with non-native dogs; or when local people favor European breeds over local dogs. Over the last two hundred years, many landrace/village-dog varieties have been developed as purebreds.

There are many more examples in this book of landraces still living in isolated regions.

Around 500 Years Ago

BRITISH VARIETIES

VICTORIAN BREEDS

HUNTING GREYHOUNDS

Varieties are separated into breeds.

SHEPHERD'S DOGS

Existing and extinct dogs (seen in art or literature) are redesigned.

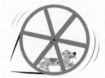

TURNSPIT DOG

Imported dogs are named and standardized.

British Varieties In England, the first English-language book on dog types by Dr. John Caius (*Of Englishe Dogges*, published in 1570) names, classifies, and ranks sixteen local varieties of dogs by their jobs and social class. These range from the "noble" hunting hounds and "lap dogs" of the wealthy to the "degenerate" dogs that work in the kitchens (e.g., "turnspit dogs" ran on a wheel to turn meat) and perform on the streets.

At this time, only wealthy people can afford to breed dogs, and these varieties fluidly overlap in terms of looks.

British Agricultural Revolution (1700s) A British farmer named Robert Bakewell invents new methods of inbreeding, which lead to the creation of new, bigger, and more uniform-looking breeds of cows, sheep, and horses.

A century later, people apply the same controlled breeding system to their dogs, and the different types of dogs multiplied! Dog breeds, as they are now called, become classified by their distinct looks.

Around 200 Years Ago in Victorian England

FANCY DOGS

"MONGRELS"

SPORTING (hunting dogs)

NON-SPORTING (show pets)

"Pure" Breeds These are types of dogs with standardized looks (focusing more on the head and face) and specialized roles. In Victorian England, owning a purebred dog is a sign of higher social status.

"Mongrels" At the same time, mongrels, curs, and pariah dogs (as they are called in Asia) are perceived as lower class and undomesticated. Across European cities, thousands of unowned free-ranging dogs become illegal and are killed.

Fashionable Breeds Breeding and showing dogs becomes a popular hobby and competitive sport called the Fancy. With new steam-powered transportation, railways, and printed mass media, fanciers can more easily travel, network, and breed more types of dogs.

At dog shows, the new breeds are classified and judged as breeding stock by how they perform in the field or measure up to official written standards for their breed. (See "Breed Looks and Standards," page 22.)

Pets or Pests? As the new breeds become cherished city pets, unowned dogs are no longer welcome on the streets. In 1860, the Temporary Home for Lost and Starving Dogs (now known as Battersea) is founded by animal welfare campaigner Mary Tealby to care for, rehome, and give these dogs a painless death. This is the first animal rescue.

FIRST RECORDED DOG SHOW CHAMPIONS

NATIONAL KENNEL CLUBS

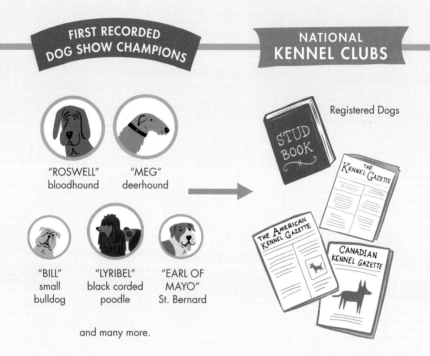

"ROSWELL"
bloodhound

"MEG"
deerhound

"BILL"
small
bulldog

"LYRIBEL"
black corded
poodle

"EARL OF
MAYO"
St. Bernard

and many more.

Registered Dogs

1860 The first National Dog Show in Birmingham, England, has thirty breeds. More shows follow in cities as far away as Hobart, Australia; Chicago, United States; and Shanghai, China.

1873 The Kennel Club (United Kingdom) is founded to register pedigrees, manage dog shows, and track show champions.

1884 The American Kennel Club becomes the first international registry with its own standards for all dog breeds. Breed clubs are formed at local and national levels, with each club's members passionate about defining, promoting, and judging their specific breed. In the news, dogs start being identified by their breed names.

Around 100 Years Ago

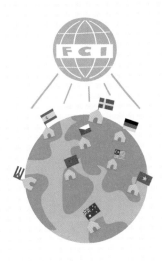

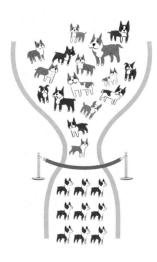

1911 The Belgium-based Fédération Cynologique Internationale (FCI) is formed. Breeds are officially recognized as belonging to different countries. Today, the FCI represents national kennel clubs in 98 countries and recognized 365 breeds, with standards that differ from the American Kennel Club's.

World Wars I and II Both wars impact the hobby and sport of creating and managing breeds, causing many European breed populations to shrink or disappear. Fanciers reconstruct or revive many breeds during this time, using dogs with similar looks and/or origins.

The definition of "purebred" changes as eugenics and nationalistic feelings reinforce an obsession with "purity" over mixed or unknown lineages and as kennel clubs restrict breeding pools to only paying members with preregistered dogs. Purebred dogs become more genetically similar.

Purebred Dogs

Other Names: Breeds, modern breeds, standardized breeds, pedigree dogs, kennel club breeds, registered breeds, single-breed dogs

The hundreds of popular breeds we know today did not evolve naturally; they are human creations: designed, standardized, exhibited, evaluated,

The Modern System

1 **Landrace/Village Dog Varieties** People select dogs with the traits they like and want to preserve.

3 **Foundation Stock** The first dogs of a breed or bloodline are isolated from mating with other dogs.

4 **Breed Standards** The ideal phenotype is decided by the breed club.

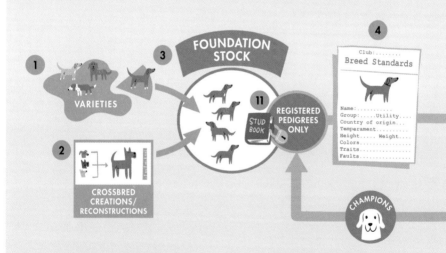

2 **Crossbred Dogs (New Designs or Reconstructions)** Sometimes different varieties are crossbred to create new combinations or to revive extinct breeds. Many modern breeds started out as "designer dogs."

10 **Competitions & Events** Dogs are evaluated to be added to the breeding pool (aka stud book).

11 **Purebred Stud Books** From the 1930s, many breed registries were closed. No new dogs were added and crossbreeding became unacceptable.

and preserved by a network of dog breeders in a system that is only around 250 years old. Although the first dogs of many breeds may be centuries-old landraces or village dogs, their descendants are products of a modern system.

So how do dogs become an official breed?

5 **Selective Breeding** Parent dogs with the desired traits are mated.

6 **Puppies** Genetics are a game of chance! Only puppies with the desired traits are bred. The others are removed from the breeding pool.

7 **Inbreeding** Over several generations, dogs are bred to their relatives to make the desired traits show up more predictably.

8 **Purebred Dogs** The result? Consistent-looking dogs with inheritable traits and pedigrees that can be traced back to the foundation stock.

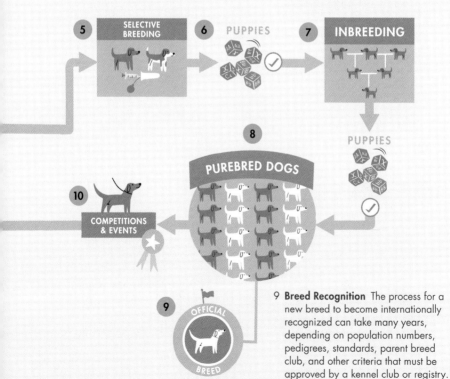

9 **Breed Recognition** The process for a new breed to become internationally recognized can take many years, depending on population numbers, pedigrees, standards, parent breed club, and other criteria that must be approved by a kennel club or registry.

BREED LOOKS AND STANDARDS

Breed standards are like design blueprints for each recognized dog breed or purebred type; they are used by fanciers around the world to keep their dogs looking consistent and identifiable as that breed, and by laypeople like me to tell very similar-looking breeds apart. Also known as conformation standards, these formal descriptions are written by breed parent clubs detailing the acceptable phenotype for the breed: ranges of heights and weights, coat colors, coat types, ear shapes, muzzle lengths, tail types, ideal gait, and ideal temperament. These standards are important for judging which dogs should be bred and which shouldn't.

At dog shows (the sport of *conformation*), dogs are judged not against each other but by how closely they conform to their own breed's standards. For instance, the winner of *Best of Breed, Best in Group,* or *Best in Show* is the individual dog that is judged to best represent its breed. Though breed standards aim to describe the ideal phenotype of a dog doing a particular historical job, sometimes the show phenotype may not be useful for the job or the job may no longer exist. Outside of the show ring, show dogs live as companion dogs.

Physical Traits

Only a few genes affect traits like leg length, muzzle length, and coat type. Beards, moustaches, and eyebrows are called furnishings in the language of the Fancy!

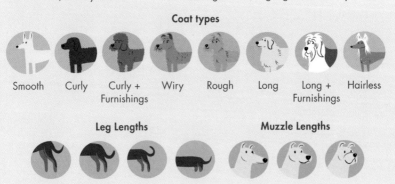

Coat types

Smooth — Curly — Curly + Furnishings — Wiry — Rough — Long — Long + Furnishings — Hairless

Leg Lengths **Muzzle Lengths**

Coat Colors

Dog coat colors mainly come in black, brown ("liver"), red, and white, with diluted variations of these colors. Color shades and coat patterns may be named differently according to the breed. For example, brown Labradors are "chocolate."

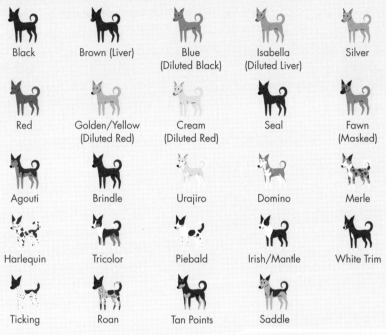

Black	Brown (Liver)	Blue (Diluted Black)	Isabella (Diluted Liver)	Silver
Red	Golden/Yellow (Diluted Red)	Cream (Diluted Red)	Seal	Fawn (Masked)
Agouti	Brindle	Urajiro	Domino	Merle
Harlequin	Tricolor	Piebald	Irish/Mantle	White Trim
Ticking	Roan	Tan Points	Saddle	

Haircuts

Show dogs are required to have the "clips" that are written in their breed standards.

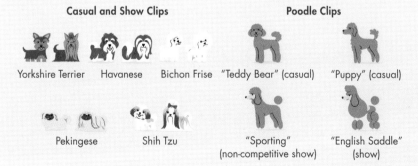

Casual and Show Clips

Yorkshire Terrier Havanese Bichon Frise "Teddy Bear" (casual) "Puppy" (casual)

Pekingese Shih Tzu "Sporting" (non-competitive show) "English Saddle" (show)

Poodle Clips

In this book, most breeds are sporting low-maintenance, casual haircuts.

CHANGING STANDARDS

Breed standards may vary from country to country. Some are more restrictive and detailed while others are more open, which can result in different interpretations by breeders and judges. Standards may also get rewritten over time.

Chow Chow

AKC 1906 "Skull flat and broad, with little stop, well filled out under the eye . . ."

AKC 1986 "Expression essentially scowling, dignified, lordly, discerning, sober and snobbish, one of independence. The scowl is achieved by a marked brow with a padded button of skin just above the inner, upper corner of each eye; by sufficient play of skin to form frowning brows and a distinct furrow between the eyes."

Bull Terrier

KC 1896 "Should be long, flat, and wide between the ears, tapering to the nose, without cheek-muscles. There should be a slight indentation down the face, without a 'stop' between the eyes."

KC 1920s "Oval, almost egg shape . . . almost an arc from the occiput to the tip of the nose. The more down-faced the better . . ."

Doberman Pinscher

AKC 1982 "Ears normally cropped and carried erect."

FCI 2015 "The ears, are left natural and of an appropriate size; they are set on either side at the highest point of the skull and are ideally lying close to the cheeks."

NON-BREED STANDARDS

Nature loves variation, so fanciers who breed pups for conformation must vigilantly select specific physical traits and not others. In other words, pups that don't conform to the breed standard are removed from the breeding pool, because purebred dogs that do not conform to their breed standards are disqualified from competing.

From the AKC's official breed standard for the Labrador Retriever:

> "[The coat] should be short, straight and very dense. . . . Woolly coats, soft silky coats, and sparse slick coats are not typical of the breed, and should be severely penalized. The Labrador Retriever coat colors are black, yellow, and chocolate. Any other colors or combination of colors is a disqualification."

Commercial demand for rare colors in purebred dogs (also referred to as fad colors) has led to breeders deliberately crossbreeding dogs to produce puppies with nonstandard colors. Sometimes these practices can be unethical, particularly with coat colors or patterns that can come with health risks.

At an Australian guide dog school that has been breeding and training Labrador Retrievers to be guide dogs for seventy years, the pups now show a wide variety of body shapes, coat types, and colors. As these pups are selected for good health and the right working temperament rather than for conformation to aesthetic standards, the natural variability in their appearance (which would disqualify them from the show ring) is not an issue.

Dogs that don't 100 percent conform to their breed standards are normal dogs! These standards are only important in the sport of conformation.

BREEDS AND HEALTH RISKS

Before genetic testing was available, breeders of purebred dogs removed pups with diseases and imperfect appearances from the breeding population by culling or sterilization. However, purebred dogs are more likely to inherit recessive and defective genes that lead to higher risk of genetic diseases and increased likelihood of passing the genes on to their offspring because of small, closed breeding pools and frequent inbreeding. Dogs from very inbred families have weakened immune systems and fertility problems. As inbreeding increases, lifespans shorten.

Inbreeding Comparisons

The coefficient of inbreeding (COI) is the number that reflects the degree of relatedness between an individual animal's two parents. In large, healthy wild animal populations, animals have a low COI of around 0 to 1 percent. Zoo animals in selectively bred programs are kept under 10 percent COI.

Purebred dogs have a COI of around 25 percent, with some breeds as high as 40 percent. A COI of 25 percent is the genetic equivalent of a dog having parents that are siblings or a father and daughter.

As if this isn't depressing enough, the extreme features that make some breeds look more interesting and unique to us cause suffering and stress in dogs that can lead to psychological and behavioral issues.

According to welfare group The International Collaborative on Extreme Conformation in Dogs (ICECdogs), when dog images in advertising and popular media continue to show "physical appearance[s] that [have] been so significantly altered by humankind away from the ancestral natural canine appearance" these extreme looks and health risks become accepted as normal.

Extreme conformation includes flattened muzzles, protruding eyes, short twisted legs, and lots of skin folds.

BRACHYCEPHALY

(flat faces, short muzzles)

- Breathing difficulties
- Overheating
- Apnea

LARGE HEAD & NARROW PELVIS
- Cannot whelp naturally
- Needs C-section

PROTRUDING EYES

- Cataracts
- Eye ulcers

TIGHTLY CURLED OR SCREW TAILS
- Spina bifada (spinal defect)

WRINKLES & SKIN FOLDS
- Skin infections

DORSAL RIDGES
(in ridgeback breeds)
- Dermoid sinus, neurological problems

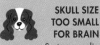

LOW BODY & SHORT LEGS
- Chondrodystrophy, intervertebral disc disease (inherited, untreatable, and painful spinal disc degeneration)

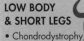

"DOUBLE MERLE"

(two merle parents and a lot of white in the coat)

- Heart and skeleton issues
- Deafness
- Blindness
- Skin issues

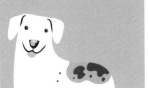

SKULL SIZE TOO SMALL FOR BRAIN
- Syringomyelia (a neurological disorder causing severe pain)

LARGE BREEDS
- Increased risk of elbow and hip dysplasia, shorter lifespans

PROGRESSIVE RETINAL ATROPHY
- Inherited eye disease that leads to blindness (high risk in many breeds including Poodles and Bedlington Terriers)

DILATED CARDIOMYOPATHY
- Irreversible heart muscle disorder (high risk in Dobermans, Boxers, and Great Danes)

COLLIE EYE ANOMALY
- Genetic disorder of the eye in Collies and Collie-related breeds

We do not yet have genetic tests available to check for all known breed-related health conditions, but there are physical and phenotypic tests for some conditions such as hip dysplasia.

HEMANGIOSARCOMA
- A deadly cancer affecting many breeds (most common in Golden Retrievers)

SAVING BREEDS

In 2011, the UK Kennel Club reopened their breed registers to accept health-tested "dogs of impure or unverified breeding" under certain conditions, to save declining breeds.

Meanwhile, veterinarians are promoting more awareness of breed-related health risks, and ethical breeding practices test potential parent dogs in advance for genes that carry diseases and for their COIs, so that high-risk dogs won't be used for breeding.

Breed communities and a few kennel clubs are coming together to increase genetic diversity in their breeds with carefully managed programs that include outcrossing (breeding unrelated dogs). Here are some examples:

Dalmatians

"Spots are round and well-defined, the more distinct the better."
—Breed Standards for both the AKC and United Kennel Club (UKC)

The spots on a Dalmatian's coat were found to be genetically linked to bladder stones (high uric acid). In a famous 1973 program, a Pointer with a healthy copy of the same gene was bred to a Dalmatian and their pups were crossed back to Dalmatians. The Dalmatian Club of America accepted these low uric acid (LUA) Dalmatians into the registry. After a long debate on whether these LUA Dalmatians were purebred enough, they were also accepted by the American Kennel Club. Now there are DNA tests to assess uric acid levels in other breeds.

Lundehunds

"The extremely low genetic diversity makes it almost impossible to breed away from the disease."
—Norsk Kennel Klub

In the 1940s, the flexible-bodied and six-toed Lundehund that had been bred specifically to hunt puffins became a very tiny, inbred population after puffins became a protected species and a distemper outbreak

infected the dogs. The breed had only four founding individuals (a COI of 80 percent) and a heritable and fatal gastrointestinal disease. Since 2013, the Norsk Kennel Klub has been crossing Lundehunds with similar Nordic breeds like the Buhund to save the breed. The pups still have six toes!

Bulldog Breeds

"Top disorders with highest risk in English Bulldog[s] included: skin fold dermatitis . . . cherry eye . . . protruding lower jaw . . . brachycephalic obstructive airway syndrome."

—Royal Veterinary College

In 2022, the Swiss Continental Bulldog was recognized as a breed by the FCI. The goal was to create a bulldog with a longer muzzle, fewer wrinkles, and open nostrils to improve their mobility and quality of life. Two other bulldog breeds with similar physical traits are the Australasian Bosdog (Australian Kennel Club) and Olde English Bulldogge (UKC). In 2021, the UK Kennel Club changed their breed standards specifying that French Bulldogs' nostrils should be visibly open.

Chinooks

"In 1965, the Guinness Book of World Records recorded the Chinook for the first time as the 'Rarest Dog in the World' . . . By 1981, there were only 11 breedable Chinook dogs in the world."

—Chinook Owners Association

In a collaboration between the Chinook Club and the UKC to revive the breed as a sled dog and family pet, non-Chinook breeds are carefully selected as new founders and crossed with Chinooks. Future pups with 80 percent Chinook in their DNA are recognized as purebred Chinooks by the UKC.

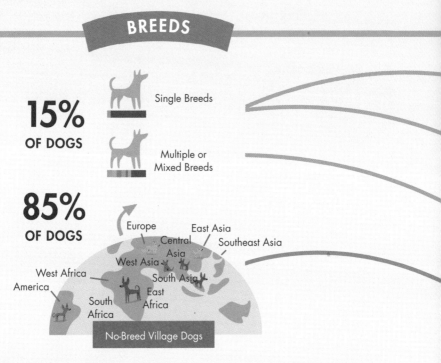

BREEDS

15%
OF DOGS

Single Breeds

Multiple or Mixed Breeds

85%
OF DOGS

Europe • Central Asia • East Asia • Southeast Asia • West Asia • South Asia • West Africa • America • East Africa • South Africa

No-Breed Village Dogs

1950s to Present In addition to working the show ring, purebred dogs are marketed as pet dog brands. Breeds also appear in movies and public media and are celebrated as national symbols.

Early 2000s Commercial DNA testing for breed ancestry becomes available. Because purebred dogs are so genetically similar, parts of their DNA can be matched to breed identities, and mutt-looking dogs can now be identified by the genetic signatures they share with single-breed dogs (see page 33).

"What breed or mix is that dog?" is now a very common question for dog owners.

2015 A Cornell University study reveals that more than 80 percent of the world's dogs are neither single breeds nor mixed breeds but no-breed village dogs; their traits are shaped by survival, not looks or standards, and they are differentiated by their shared genetics with dogs from the same geographical region.

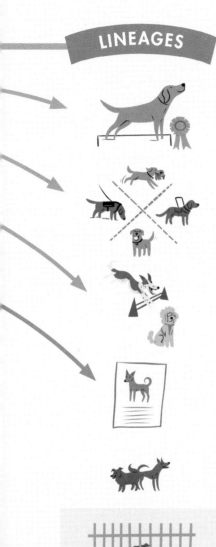

LINEAGES

Modern breed dogs are not uniform populations. Dogs' bodies and personalities are shaped by genetics and different cultural environments rather than by breed status or looks alone.

Purebred—Different Standards Purebred dogs can show very different physical traits and/or behavioral tendencies due to different countries' breeding policies, systems, and standards (e.g., British Labrador Retriever versus American Labrador Retriever, German Shorthaired Pointer versus Deutsch Kurzhaar).

Same Breed—Different Lines Within a breed, show lines, field/sports lines, hunting lines, working lines, service lines, and pet lines can all have very different temperaments and body shapes to be best suited for their niches (e.g., a show Labrador versus a service Labrador).

Purpose-Bred Mixes These are crossbred dogs intentionally bred for dog sports (e.g., flyball mixes), pet lifestyles (e.g., Doodles), or service work (e.g., Labernese). Ethically bred dogs have well-known and healthy parents.

Landrace Breeds These are indigenous dogs with their natural traits or more flexible breed standards that live as companion dogs. Some are in the process of becoming formally recognized as breeds.

Free-Ranging Dogs If we don't know their family histories or DNA profiles, these could be single breed, mixed breed, or no-breed village dogs (see page 14). They choose their own mates!

Shelter/Rescue Dogs: Dogs from all lineages end up in shelters, usually as a result of poverty, incompatible human-dog relationships, and unethical breeding. Adoption is a popular and compassionate way to get a new dog.

Mixed-Breed Dogs

Other Names: Mutts, mixes, mongrels, Heinz 57s, "All-American Dogs" (AKC), regional names

When we talk about mixed-breed dogs, we are usually referring to pups whose dog parents were not chosen by people for the purpose of creating or adding to a breed. Most European and North American dogs are mutts!

Mutts have diverse looks and genes, and DNA tests will typically show that a mutt has at least 75 percent of shared ancestry with four or more breeds. This is because single-breed or purebred dogs have been intentionally created from the *same ancestors* as mutts, and not always because there were purebred dogs somewhere in a mutt's family tree. In more rural parts of the world, dogs that look like mutts may in fact be village dogs that have no breeds in their ancestry.

There is no way to know which breeds are part of a mutt's genetic makeup just by looking—even if it's fun to guess! Genes randomly reshuffle as they get passed down the family tree, so, in only two generations, puppies can look very different from their grandparents.

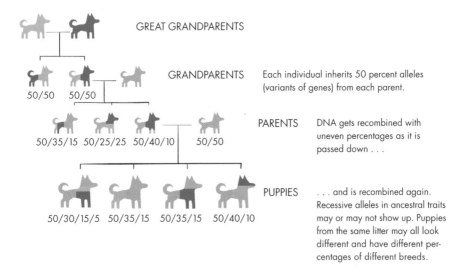

GREAT GRANDPARENTS

GRANDPARENTS
50/50 50/50

Each individual inherits 50 percent alleles (variants of genes) from each parent.

PARENTS
50/35/15 50/25/25 50/40/10 50/50

DNA gets recombined with uneven percentages as it is passed down . . .

PUPPIES
50/30/15/5 50/35/15 50/35/15 50/40/10

. . . and is recombined again. Recessive alleles in ancestral traits may or may not show up. Puppies from the same litter may all look different and have different percentages of different breeds.

HOW BREED DNA TESTS WORK

A breed DNA test's accuracy depends on the number of DNA segments tested and which breeds are in the testing laboratory's Breed Reference Database. This database is created from sample DNA taken from groups of purebred or village dogs. The number and diversity of dogs in the reference breed samples will affect the results.

If a particular breed is not in the database, the algorithm gives the closest estimate (a breed with a shared ancestor) or produces an "unknown" or "other" result. Sometimes the DNA segments may be too small to confidently match to breeds in the database; in which case, the result is "Supermutt" or "unresolved." As the database gets updated with more breeds and samples, the results of a dog's DNA test may change!

Accuracy also depends on the technology used. Most tests can only accurately account for a dog's past three generations. Some tests may be accurate with breeds detected below 25 percent but not below 10 percent. In general, the larger the percentage, the more we can trust the information.

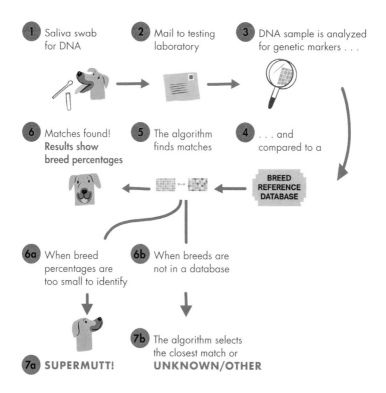

1. Saliva swab for DNA

2. Mail to testing laboratory

3. DNA sample is analyzed for genetic markers . . .

6. Matches found! **Results show breed percentages**

5. The algorithm finds matches

4. . . . and compared to a

BREED REFERENCE DATABASE

6a. When breed percentages are too small to identify

6b. When breeds are not in a database

7a. **SUPERMUTT!**

7b. The algorithm selects the closest match or **UNKNOWN/OTHER**

RIO

39% Australian Cattle Dog
31% Shetland Sheepdog
19% Chihuahua
11% Supermutt

BEN

46% Supermutt
16% Treeing Walker Coonhound
13% American Pit Bull Terrier
13% Norwegian Elkhound
12% Chow Chow

JENNY

25% Unknown
25% Supermutt
22% Labrador Retriever
15% Rottweiler
13% Samoyed

MOE

49% American Staffordshire Terrier
20% Miniature Poodle
13% Supermutt
10% Chihuahua
8% Shih Tzu

SCARLET

43% Supermutt
32% American Pit Bull Terrier
13% Chow Chow
12% Labrador Retriever

SEE KAO

100% Southeast Asian
Village Dog*

*Accuracy of geographical
region depends on the sampled
dogs in the database.

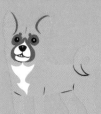

JILLY

37% Supermutt
22% Presa Canario
18% Cane Corso
13% Pomeranian
10% American Staffordshire Terrier

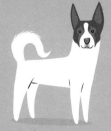

KENZI

32% Siberian Husky
25% German Shepherd Dog
17% Russell Terrier
16% Boston Terrier
10% Supermutt

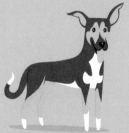

RIG

44% Border Collie
42% Whippet
9% Border Terrier
5% Malinois

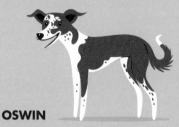

OSWIN

50% Border Collie
50% Whippet

KASPER

50% Malinois
25% Boxer
14% Rottweiler
11% German Shepherd

KONA

100% German Shorthaired Pointer*
(see page 106)

*Not all single-breed dogs conform
 to their breed standards.

2

Breed and Personality

You may have heard that Labrador Retrievers are "friendly," or Chihuahuas are "yappy." Official breed standards also come with temperament descriptions, like the examples on this page. It's important to know that these are projections of how an ideal specimen of this breed will behave compared to dogs in general. Ideal personality traits were created to market purebred dogs, and these tell us more about people's expectations and biases than about the dogs themselves. Breed plays a part in personality but is not the only part or even the biggest factor!

French Bulldog
"Sociable, lively, playful, possessive." (FCI)

Border Collie "Borders are among the canine kingdom's most agile, balanced, and durable citizens." (AKC) "Keen, alert, responsive and intelligent." (FCI)

Shiba Inu "Faithful, with keenness in sense and high alertness." (FCI)

Anatolian Shepherd "As dominating and demanding as he is calm and loving." (AKC)

Borzoi "A bit too dignified to wholeheartedly enjoy a lot of roughhousing." (AKC) "Attitude towards people is neutral to friendly." (FCI)

Chihuahua "Without [training] this clever scamp will rule your household like a little Napoleon." (AKC) "Quick, alert, lively and very courageous." (FCI)

Irish Terrier "Once he is attacked, he has the courage of a lion and will fight to the bitter end." (FCI)

Nature and Nurture

A dog's personality is formed by an intricate interplay of multiple genes and environment. Twenty percent or less of the variation in most personality traits is caused by genetics—just as human siblings are not carbon copies of each other! Scientists have not yet found the gene-gene and gene-environmental interactions to explain personality in dogs—or any other animals.

Breeds Are Not Uniform Populations

In terms of personality traits, it is more helpful to think of each breed as a bell curve of averages. There are always outliers! For example, many Labrador Retrievers may be dog friendly, but there are some that are more dog selective—and this is totally normal! Although Labs might on average be friendlier to other dogs than Chihuahuas are, both breeds contain a similar average number of dog-friendly and dog-selective dogs.

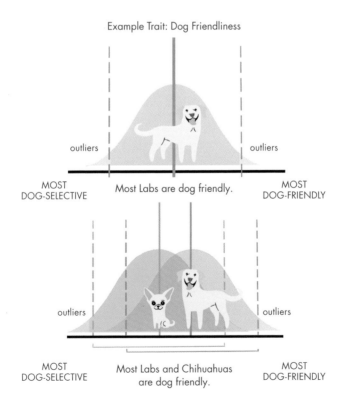

Example Trait: Dog Friendliness

outliers outliers

MOST
DOG-SELECTIVE Most Labs are dog friendly. MOST
DOG-FRIENDLY

outliers outliers

MOST
DOG-SELECTIVE Most Labs and Chihuahuas MOST
 are dog friendly. DOG-FRIENDLY

Personality Labels Are Often Subjective Judgments

How we describe or label a breed's behavior and personality is often subjective and inseparable from specific contexts and social expectations. When personality labels stick and become stereotypes, we may be tempted to assume that normal dog behaviors are caused by their breed, when they are not.

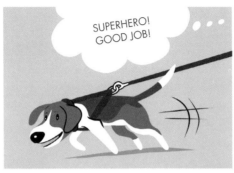

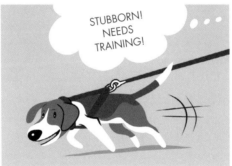

A working scent-detection Beagle versus a pet Beagle.
The same leash-pulling behavior, different personality labels!

Personality Variation

There is more variation in personalities within a breed than there is between different breeds.

A quote I frequently hear from dog behavior consultants is, "See and love the dog in front of you, instead of the one in your head."

Genetics and Personality Traits

These eight personality traits are taken from a 2022 citizen science survey by Kathleen Morrill and team, featuring more than two thousand pet dogs—both purebred and mixed breed. The results showed that traits 1, 3, and 4 have a stronger genetic component than the others, and we can see that personality labels, like "human sociable" and "independent," are also context dependent.

In other words, a dog's family history can provide some clues to how human-sociable, toy-directed (predatory), or biddable (collaborative with humans) they are, while at the same time, the dog's environment is inseparable from how these personality traits are expressed. For example, companion lines are more likely to remain relaxed or interested around new people than guardian lines that are more likely to be wary of strangers. A sports-bred dog is likely to be more biddable than a dog bred to work independently or with a free-ranging background. (More on these dog types and roles in chapter 3.)

These levels can also change with a dog's age and life experiences. Older dogs are generally calmer in arousal level than younger dogs of any breed. Puppyhood experiences, health issues, and pain (which is not always obvious to us) can affect sociability and other behaviors. A dog that "overreacts" in uncomfortable situations (low agonistic threshold) can learn to be more relaxed or, with the right social support and environment, learn to communicate their discomfort in other ways.

TRAITS	LOW	HIGH

1 Human Sociability
with Strangers

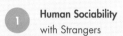

Wary, stranger shy, introverted

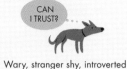

Wants to meet
every person, extroverted

2 Arousal Level
with Exciting Events

Laid-back

Revved! Sustained enthusiasm

**3 Toy-Directed
Motor Patterns**
with Toys

Ignores toys

Can't get enough of playing

4 Biddability
with Human Cues
and Instructions

Independent, self-directed

Looks to people
for guidance and direction

**5 Agonistic (Aggressive)
Threshold**
in Unfamiliar or
Uncomfortable Situations

More likely to assert or
express discomfort

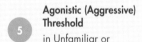

Easygoing

6 Dog Sociability
with Other Dogs

Solo dog, dog selective

Loves interacting
with other dogs

**7 Environmental
Engagement**
on Their Home Turf

Nonchalant, has an off switch

Curious, always busy or
searching for stimulation

**8 Proximity Seeking/
Touch Seeking**
within Personal Bubble
of People

Prefers social distancing,
hands-off affection

Physically affectionate,
cuddly, seeks touch

Predatory Motor Patterns

You may have heard that some breeds have a "strong working instinct," "high prey drive," or even "toy drive." What does this mean?

We often think of **predation** as chasing and killing, but these are only two parts of the sequence. The full predatory sequence starts with HUNTING or SEEKING and ends with CONSUMING; and these are very normal, biological needs in dogs.

What makes dogs different from wild animals is that dogs have evolved with humans and do not need to hunt to survive. Domesticated dogs are flexible

WILD TYPE PREDATORY SEQUENCE	HUNT (Seek)	ORIENT (Attention)	EYE (Focus)	STALK (Approach)
Breed Types				
Hunting hounds may do most parts of the sequence except DISSECT and CONSUME.				
Herding dogs move animals without attacking or killing.	X		Headers	
Livestock guardians that display any predatory behaviors toward livestock are not used for guarding.	X	X	X	X
Pointing dogs HUNT and stop at ORIENT or EYE without chasing.				X
Retrievers are more motivated to HUNT and POSSESS things with their mouths (instead of GRAB-BITE).			X	
Bulldogs/catch dogs and bite sports dogs have a strong GRAB-BITE (holding, without killing).				
Terriers, whose traditional job is pest control, HUNT, GRAB-BITE, and KILL-BITE (aka head shake).				
Scent-detection dogs HUNT and rewarded with toy play (GRAB-BITE and POSSESS) or food (CONSUME).		MARK!		

in how they express their predatory behaviors and do not need to follow the strict sequence as wolves do.

These predatory motor patterns are in the DNA of all dogs and are not breed specific. However, in selecting for working traits, humans have rewired dogs' brains so that dogs from working lines are more likely to express certain behavior patterns in modified or exaggerated ways given their genetics and environment, while dogs from show lines or pet lines (that are bred more for looks and human sociability) may express these behaviors in more subdued ways or less frequently.

Every dog is an individual, and depending on the context, each dog will be more motivated by some behaviors over others.

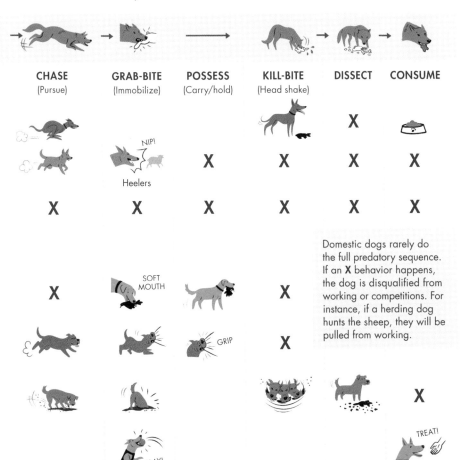

CHASE (Pursue)	GRAB-BITE (Immobilize)	POSSESS (Carry/hold)	KILL-BITE (Head shake)	DISSECT	CONSUME

Domestic dogs rarely do the full predatory sequence. If an **X** behavior happens, the dog is disqualified from working or competitions. For instance, if a herding dog hunts the sheep, they will be pulled from working.

3

Dog Types and Their Roles

All around the world, dogs help people hunt for food, herd, and guard livestock. The 30-pound livestock guardian dogs in Botswana look nothing like the 70-pound livestock guardian breeds in Italy, but they do the same job. A variety of purebred and mixed-breed dogs have been trained in scent-detection work. Dogs that are not herding breeds can herd. Dogs that aren't retriever breeds can retrieve. Dogs that are not hunting breeds can track or point.

While any dog can be trained to do any behavior, working lineages have been selectively bred over many generations to have higher levels of specific behavior patterns, the body shapes that make performing these patterns easier, and higher levels of collaboration with humans (aka biddability) than other types of dogs. Instead of being expected to conform to standards of appearance, working dogs must conform to standards of performance for their roles.

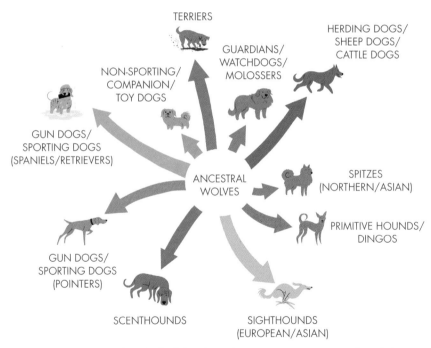

A 2022 genomic study of hundreds of dogs by Emily V. Dutrow, James A. Serpell, and Elaine A. Ostrander identified ten major domestic genetic lineages that correspond with historical breed occupations and geography. These are lineages that existed before purebred dogs were created 250 years ago, and they loosely correspond with kennel club breed groups.

Herding Dogs

Other Names: sheepdogs, shepherds, collies (United Kingdom), cattle dogs, working dogs (Australia), stock dogs, pastoral dogs

Herding dogs work with farmers to gather and move large numbers of sheep or cattle from pasture to farm and vice versa. They are hyperaware of sounds and movements in their surroundings including the body language of the livestock animals and humans they collaborate with. Different breeds and individual dogs are known for different herding styles.

Border Collies and New Zealand Heading Dogs use "eye"—a fixed stare and low, stalking style—to move sheep.	Heelers like Cattle Dogs and Corgis chase, bark, and nip from behind.	Australian Shepherds work "loose-eyed" (without staring) and upright.	German Shepherd Dogs and other Continental Shepherds "tend their sheep" by moving around them like a "living fence."

Good herding dogs never attack the animals they manage. Recently, a gene found in herding breeds—called EPHA5—that is associated with attention-deficit/hyperactivity disorder in humans has been used to explain these breeds' high energy and obsessive focus on tasks. Another of their genes—called EFNA5—is correlated with maternal "pup-gathering" behaviors.

Livestock Guardians

Other Names: LGDs, sheepdogs, shepherds, flock guardians (UKC), mountain dogs (long coats), Mastiffs (short coats), protection dogs, guard dogs

Livestock guardians stay with and protect sheep, goats, and cattle from wild predators by patrolling, scent marking, barking, and chasing the predators

away (so the wildlife is not killed by farmers). In nomadic pastoral societies, LGDs may travel over long distances with their flock. Unlike herding dogs, guardians don't move their animals; they move with them. Ideal guardians are low-energy dogs that can chill out for long periods but have a heightened sensitivity to boundaries and strangers entering their territory. In urban environments, guardian types are employed to protect houses and property instead of animals.

Many livestock guardian breeds are ancient landraces that have adapted to their native habitats over thousands of years. For example, a gene called EPAS1 found in Tibetan Mastiffs and related breeds makes them more tolerant of low-oxygen environments and less susceptible to altitude sickness.

Livestock guardians are socialized from puppyhood with the animals they protect; they are bonded to them and trusted by them.

Kennel Club Breed Groups

Within the kennel club system, breeds have been classified into different groups based on their ancestors' working heritage. The group names vary from club to club.

- The **American Kennel Club** (AKC) currently recognizes 200 dog breeds and classifies them into 7 groups.
- **United Kennel Club** (UKC): more than 300 breeds in 8 groups.
- The United Kingdom–based **Kennel Club**: 222 breeds in 7 groups.
- The European **Fédération Cynologique Internationale** (FCI): 356 breeds in 10 groups with subgroups.

Breed group classifications also vary from club to club.

- The Japanese **Shiba Inu** is in the AKC's "Non-Sporting" group, the UKC's "Northern" group, and the FCI's "Spitz and Primitive Types (Asian Spitz)" group.
- The German **Leonberger** is in the AKC's "Working" group, the UKC's "Guardian" group, and the FCI's "Molossoid" (Mountain Dogs) group.
- The Israeli **Canaan Dog** is in the AKC's "Herding" group, the UKC's "Sighthounds and Pariah" group, and the FCI's "Spitz and Primitive Types" group.

Outside of these formal categories, dogs may have more than one role, fit within more than one type, and do more than one job.

Terriers

Other Names: earth dogs, feists (used for squirrel-huntings in the United States), pinschers, schnauzers (Germany), ratting dogs

Traditionally, the job of a terrier is to hunt and kill small animals (like rats and squirrels) as a form of pest control and to serve as alert-barking watchdogs. In Victorian times, city terriers were also used in rat-killing contests for gambling purposes. Terriers are valued for their high energy and their ability to be easily triggered by the movements of small animals and to work tenaciously and independently. Their smallish bodies allow them to fit into holes and tight spaces.

When rat poison became popular in the 1940s, many terrier breeds went into decline. Today's urban terriers are small companion dogs.

Bulldogs

Other Names: catch dogs, bullbaiting dogs, bully breeds, bully types

Bulldogs have shorthaired coats, squarish heads, shorter muzzles, and stocky muscular bodies. The role of bulldogs has changed over time. Premodern British bulldogs were hunters' and butchers' "catch dogs"— trained to use their teeth and body weight to hold onto large wild animals or livestock animals until humans arrived. Valued for their physical strength and stamina, they were crossed with terriers and used for bullbaiting (where dogs were set up to fight tethered bulls for gambling and entertainment) and dog fighting (where dogs were set up to fight each other). These cruel bloodsports were banned in nineteenth-century England.

Modern bully types (English Bulldog, French Bulldog, Pug, and so on) are bred for their looks and strong emotional attachment to people.

Scenthounds

Other Names: hounds, hunting dogs, trailing hounds

Scenthounds are European hunting dogs that specialize in tracking a scent for long distances and bark-howling ("baying") very loudly and persistently to indicate having found the scent. They generally have long snouts, floppy ears, and bodies built for endurance tracking. They are extra sensitive to nonvisual cues and highly motivated to follow these cues, and they are traditionally bred to work independently or on leash.

Sighthounds

Other Names: gazehounds, running hounds, Greyhounds, Lurchers

Sighthounds have deep-chested muscular physiques, long legs, tucked waists, different coat lengths, long narrow muzzles, and wide peripheral vision. They were traditionally bred to hunt by sight and speed over long distances in open deserts or grasslands. Depending on the hunting culture, some sighthounds drive the prey toward the hunter; others are bred to chase and grab onto the prey.

In modern times, sighthounds have been selectively bred for coursing and racing events. Some modern sighthound breeds (for instance, the Silken Windsprite) have been designed to be sporty companion dogs.

Cruel Traditions

Cultures of poor welfare have been connected with hunting dogs and sighthounds. For example, on the Iberian Peninsula, Galgos and Podencos are used in large packs as hunting dogs, then abandoned or killed at the end of each hunting season. Greyhounds that have been selectively bred for the racing industry spend most of their time in cages, suffer injuries from racing, and are disposed of when injured. Thankfully, many dogs have been rescued from these traditions to become companion dogs.

Primitive-Type Dogs

Other Names: indigenous (village) dogs, Dingo-type dogs. This group also includes some sighthounds and Spitzes.

Primitive refers to a body shape that has not undergone the selective breeding process that created the diverse looks of modern European breeds. Primitive-type dogs—with their wedge-shaped heads, upright ears, and curly tails—are believed to look like the very first domesticated dogs of many thousands of years ago. The smooth-coated dogs evolved in warm climates and the longhaired Spitzes evolved in the colder north.

These dogs have various jobs throughout the world: hunting, livestock herding, danger detection, extermination of vermin, and companionship. Depending on their early experiences and environment, they may show more predatory behaviors (see page 42) than other types of dogs. Some primitive-type dogs yodel instead of bark.

The "primitive" label can cause some confusion because it is applied to both recognized breeds and indigenous dogs/landraces/village dogs.

Spitzes

Regional Types: North American, Northern European, Eurasian, East Asian

Spitzes look foxlike or wolflike and are indigenous to the colder northern regions of the world. They have upright ears, pointy snouts, long dense coats, and thick bushy tails that usually curl over their backs.

Spitzes have different roles depending on the geographical region and culture. In the Arctic North, they are bred for sled pulling, hunting, reindeer herding, and guarding. Modern spitz types have been developed for winter dog sports or to be companion dogs.

Gun Dogs

Other Names: bird dogs, sporting dogs, hunting dogs

Gun dogs are a class of British and European dogs that were bred and trained as bird-hunting companions after the modern shotgun replaced older hunting methods like using falcons and crossbows. In Victorian England, these dogs became specialists in specific hunting tasks.

Gun Dogs on Show

The very first dog show, which took place at an agricultural event in 1859 in Newcastle upon Tyne, featured pointers and setters and was hosted by a gun company with guns as the prizes.

POINTING DOGS

Other Names: pointers, Braques (smooth coats), setters and Épagneuls (longhaired coats), Griffons (rough-haired coats)

Pointing dogs specialize in seeking out game birds and indicating the bird's position to the hunter without pursuing the bird. What hunters call pointing is the pause or moment of stillness when prey is detected right before the dog moves forward by chasing or pouncing. Technically, all predatory animals point—not only dogs and not only pointing breeds. However, pointers and setters have been selectively bred to *stop dramatically* at this part of the predatory sequence. Pointing behaviors can even be seen in puppyhood.

Pointing dogs are trained to stop and wait when another dog is pointing. This is called honoring or backing a point.

FLUSHING DOGS

Other Name: spaniels

A spaniel's specialty is to hunt silently, swiftly, and methodically within shotgun range. With their protective long or curly coats, they are better adapted to moving through dense bushes and uncertain terrain than smooth-coated dogs. When they have located a bird, they flush or spring the bird into the air for it to be shot, then they sit and wait for the cue from the hunter to retrieve the bird. Spaniels are bred to be enthusiastic, collaborative hunters with a love of chasing and retrieving.

Water Spaniels and water dogs swim and retrieve waterfowl.

"Quartering" and "bracketing" are hunting behavior patterns characterized by zig-zagging movements, working with the wind direction to narrow down the source of an odor.

Names Can Be Misleading!

- Some small breeds named spaniels are nonhunting breeds.
- An Épagneul (the French name for "Spaniel") is a pointing dog.
- Spaniels are not from Spain; they're British!

RETRIEVERS

Other Name: water dogs

Retrievers were bred to retrieve shot birds and bring them back to the hunter with a "soft mouth" so as not to damage the prey. They also have webbed feet and water-resistant coats for working in water.

While any dog can be taught to fetch, retrievers are bred for high biddability. Today, retrievers are also scent-detection dogs, family pets, and assistance dogs to help people with their mobility.

VERSATILE GUN DOGS

Other Names: HPR (Hunt, Point, and Retrieve) dogs, multipurpose hunting dogs

These are British and European gun-dog breeds that perform all hunting-related tasks in all terrain—land and water—and have passed tests in all these tasks. In some European countries like Germany, only tested and documented HPR dogs are legally permitted for hunting and breeding.

Assistance Dogs

These are individual dogs of any breed or type with some distinctions:

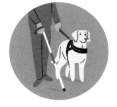

Service dogs or guide dogs are highly trained to assist people who have physical and mental disabilities, allowing them more independence and mobility. Dogs that work as guide dogs are calm, independent thinkers and able to concentrate on their job in a variety of environments despite distractions and novel situations.

Medical-alert assistance dogs are service dogs or companion dogs with special skills. They can sniff out changes in their human's body and warn them ahead of a potentially life-threatening episode (e.g., a diabetic crises, migraines, and epileptic seizures).

Fuzzy Monster Truck is a Toy Australian Shepherd/Chihuahua mix who alerts and brings his human their migraine medication.

Emotional-support dogs help and comfort individuals with a mental or physical disability. They are often confused with service dogs but are not allowed to enter spaces where general pet dogs (non-service dogs) can't go.

Therapy dogs visit schools and hospitals with their handlers to provide comfort to people.

Scent-Detection Dogs

Other Names: sniffer dogs, detection dogs

These can be individual dogs of any breed including shelter mutts.

According to organizations that employ dogs for their sniffing powers, what makes a good scent-detection dog is more than just sniffing ability. These dogs must be physically healthy, have lots of energy and stamina, be confident in a variety of environments, have a strong bond with their handler, and have extremely high motivation to work for their favorite reward, which can include toy play or a special food item.

As with assistance dogs, there are some distinctions:

Wildlife-conservation dogs use their powerful noses to sniff out endangered species by their pheromones or scat so that they can be protected. These dogs can also find invasive species that need to be eradicated.

Meet Willow: This Labrador Retriever's various talents include searching for Eastern Box Turtles. Her paycheck: a soft, squeaky rubber ball.

Meet Bear, a Border Collie–Koolie mix who helps find koalas in areas destroyed by bushfires.

Anti-wildlife-trafficking dogs and their handlers work together to disrupt animal poaching and trafficking. They can track the scent of poachers and smuggled wildlife and wildlife parts, and they can help apprehend poachers so that they can be arrested.

Search-and-rescue dogs and their handlers are trained and certified to search for missing persons in a variety of different environments, such as disaster sites, avalanches, water, and wilderness terrain. They alert their handlers by barking and scratching the ground where the scent is strongest or leading their handler back to the scent.

Medical-detection dogs have been trained to detect cancer and other diseases in humans. In 2023, studies from thirty-two countries using nineteen different dog breeds showed that dogs could sniff out the COVID-19 virus in a matter of seconds, which is a less-invasive and faster screening method.

Explosives (bomb)-detection dogs work with security agencies to protect public safety. They are highly trained to detect chemical compounds in explosives, accelerants, hidden weapons, and ammunition at places like airports, mail rooms, and cargo facilities.

Narcotics-detection dogs sniff out hidden illegal drugs.

Bed-bug-detection dogs are used for pest control.

Electronic-detection dogs can locate anything with a circuit board and are often used in fighting cybercrimes.

Sports Dogs

Other Names: sports-bred dogs, performance sports dogs, sports mixes

These are individual pet dogs from any breed, including mixed-breed dogs, that have been intentionally bred to do dog sports. Dog sports are just-for-fun or competitive events for dog and human teams, organized by local clubs or kennel clubs. Here are some examples.

 Conformation is exclusive to registered purebred (show line) dogs, which are judged for looks and gait according to their breed standards.

 Trials are competitive events designed specifically for registered hunting, herding, and terrier breeds in simulated hunting or working situations.

 Lure coursing simulates the unpredictability of live prey as dogs chase a mechanized lure around a course.

 Nosework and tracking simulate the sport of hunting as dogs search for specific hidden odors.

 Disc dog involves catching a flying disc at various distances.

 Flyball is a competitive event with dog-human teams participating in a fast-paced relay race with hurdles and balls.

Pull sports are races where dogs in harnesses pull their humans on skis, sleds, scooters, and bikes.

Agility races are timed obstacle courses for athletic, high-energy dog-human teams.

Dock diving involves dogs making the biggest leap possible (to catch a toy) from a stationary dock into a body of water.

Weight pulls involve dogs pulling a cart or sled loaded with weight a short distance across different surfaces.

Barn hunts are obstacle courses in barns where dogs have to find a hidden rat in a tube. (Rats are not physically harmed!)

Bite sports are exercises in which dogs jump and bite on cue—like police dogs are trained to do.

Treibball is an urban sport where dogs "herd" giant inflatable balls.

Rally and competition obedience are the performance of movements on cue as a handler-dog team.

Companion Dogs and Toy Breeds

Other Names: non-sporting dogs, nonworking dogs, pet dogs, family dogs

A companion or pet dog's purpose is to live indoors, offering emotional support to their people. They are selectively bred for a stronger social attachment to and dependence on humans than on other dogs, and to be less predation motivated.

Before the nineteenth century, only royalty and wealthy people bred and kept pets. When pet-keeping first became a middle-class hobby in Victorian England, the "Toy" group was created by the Kennel Club to classify small dogs that were bred not for any specific work or sport but for their tiny size and looks. These included "lap dogs" and smaller dwarf versions of other breeds. Back then, small dogs were feminized and considered to be less intelligent than the sporting (hunting) breeds that belonged to men. To this day, small dogs are frequently misunderstood and placed in situations that make them vulnerable and less free to make choices. For example, small dogs are often picked up instead of called over; get less training, play, and enrichment than larger dogs; and their expressions of discomfort (barking, snapping, etc.) tend to be laughed at or dismissed.

Even in the twenty-first century, myths and misunderstandings around dog behavior persist, along with the belief that some (usually larger) breeds need a heavier hand in training than other breeds.

Fortunately, in many countries around the world today, collars and training devices that startle or cause pain have been banned, and we know that dogs can be successfully trained using kindness and rewards. There is more education available on learning to read a dog's body language and how to offer pet dogs a better quality of life.

Today, companion dogs can be any breed or size.

Pet Dogs

Ownership of dogs is often taken for granted as the default relationship between humans and dogs and rarely seen as a situation that has been normalized for some groups of people and not others.

For instance, there was a time when it was illegal for poor people to own Greyhounds, and in some cultures, it is socially acceptable to own dogs only as working animals, not pets.

Cultural customs and utilitarian views often limit people's capacity to see dogs as thinking, feeling individuals worthy of agency, good welfare, and compassion.

In the Americas, dogs have been used by white colonizers and governments to terrorize Indigenous Americans and enslaved African Americans. Until the late 1800s, it was a crime for Black Americans to own dogs. Living with a companion dog would incur punishment or taxes. To this day, there are inequities that make it hard for people to live safely with their dogs and have access to medical and other resources, and breed-specific laws that threaten human-dog bonds.

In the Western urban society that I live in, the pet role is often assumed to be what dogs are born to do and how they should live. But that's not true everywhere. In most of the world, dogs are not perceived as our best friends and do not live indoors or sleep in beds.

Free-Ranging Dogs

Other Names: outside dogs, stray dogs, free-living dogs, street dogs, village dogs, community dogs

There are close to a billion dogs in the world whose identities are not connected to specific functions or breed lineages, and whose family histories are unknown. Different environments shape the experiences of these dogs. For instance, the lives of city street dogs are very different from those of most free-ranging rural dogs.

City street dogs live outdoors in urban environments and have historically been perceived in colonial societies as lower rank or less valuable than purebred dogs. They are treated either as commensals (harmless creatures that use us for their needs) or as dangerous pests (that may have rabies) to be removed from public spaces. People's attitudes toward street dogs vary.

A street dog eating out of a feeding station set up by people in their community.

Street dogs suffer from uncertainty about their next meal, traffic, harsh weather, untreated parasites and diseases, abusive humans, and conflicts with other dogs over territory and limited resources. The ones that survive have had to develop some skills so that they can cross streets without getting hit, beg for food, and make dog friends. Most important, they survive because they are protected by small groups of animal lovers or individuals who feed, spay or neuter, and vaccinate them; give them medical care; and report human cruelty.

Free-ranging rural dogs live outdoors in small rural villages or less urban areas and have relatively more peaceful lives. Although they usually don't get medical care, they are generally appreciated by local people, have lots of open spaces for resting and playing, and can do natural dog things like reproduce.

Ethological observations into the daily lives of free-ranging dogs open our eyes to a kind of agency that

pet dogs rarely get to experience and enjoy. Free-ranging dogs can choose their own dog friends and people to bond with. They learn through observation and experience rather than any formalized training; they may wander, play, poop, and sleep wherever they please. By contrast, pet dogs live in restricted conditions, have their social and reproductive lives micromanaged, are often

expected to behave in polite ways unnatural to dogs, and are usually left alone for hours each day.

Like all dogs, free-ranging dogs are individuals. Some prefer the outdoor life; others adapt to adoptive homes, forming deep, lasting relationships with the humans they live with.

Some important distinctions:

Stray dogs are pet dogs that have been abandoned by people or that have strayed from their homes. They may or may not be well-adapted to surviving on the street. Not all street dogs are strays.

Feral dogs or wild dogs are dogs that are very shy and scared of people and live on the outskirts of human-occupied towns or villages. Most street dogs or free-ranging rural dogs are not feral; they are comfortable eating and sleeping near people.

Community dogs often get confused with stray dogs or feral dogs. They are free-roaming members of a village or district, and their relationships with people vary from place to place. People's attitudes toward these dogs can range from dislike and neutral disinterest to appreciation and empathy. Free-ranging dogs that are accepted members of a community have names, are fed, and are cared for by people in that community; these dogs may watch over certain homes even if they are not treated as private property or kept indoors.

4

Breeds, Landraces, and Mutts by Geographical Origin

In the following pages are breeds and types of dogs from different regions of the world. Many are internationally recognized by kennel clubs; many are not.

Guide to the Dogs

Within each broad geographical region, the dogs are grouped by country then loosely by type or job. Each of the illustrations includes the breed's official name and other known names, their country or place of origin, general size, and original working role.

Fun fact: The illustrations of village dogs are portraits of real dogs from their countries of adoption. Remember, village dogs are not breeds. They do not have specific nationalities. Their broad regional designations come from DNA analysis.

GENERAL SIZE
Given according to height at the dog's withers (shoulder).
Small: Under 18 inches/45 centimeters
Medium: 18 to 25 inches/45 to 63 centimeters
Large: 25 to 30 inches/63 to 76 centimeters
Giant: More than 30 inches/76 centimeters

ABBREVIATIONS
AKC: American Kennel Club (United States)
UKC: United Kennel Club (United States)
FCI: Fédération Cynologique International (Europe)

Disclaimer: I have drawn a few breeds with cropped ears or docked tails. Though the practice of surgically removing dogs' ears and tails has been banned in many European countries, it is still common in many places around the world, including the United States. These illustrations are not an endorsement of these practices.

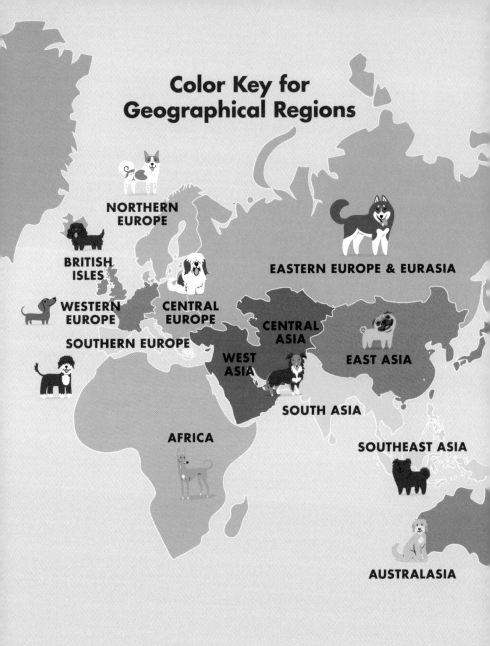

Color Key for Geographical Regions

NORTHERN EUROPE

BRITISH ISLES

EASTERN EUROPE & EURASIA

WESTERN EUROPE

CENTRAL EUROPE

CENTRAL ASIA

SOUTHERN EUROPE

WEST ASIA

EAST ASIA

SOUTH ASIA

AFRICA

SOUTHEAST ASIA

AUSTRALASIA

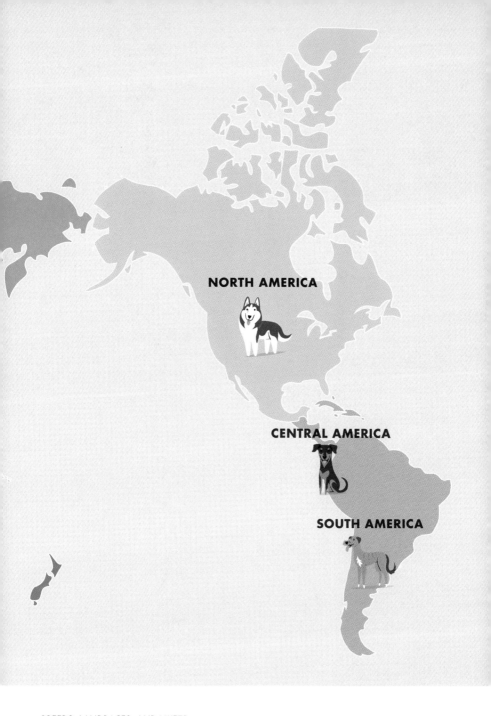

NORTH AMERICA

CENTRAL AMERICA

SOUTH AMERICA

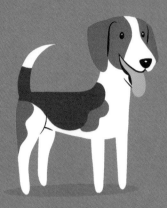

English Foxhound
ENGLAND
Medium fox-hunting scenthound
followed by huntsmen on horseback.

Harrier
ENGLAND
Medium hare-hunting scenthound
followed by huntsmen on foot.

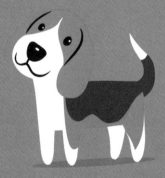

Beagle
ENGLAND
Small rabbit-hunting scenthound.
Today, they are airport scent-detection
dogs and very popular companion dogs.

Basset Hound
ENGLAND
Small scenthound first created by
crossbreeding a French Basset and a
Bloodhound. Also, the first time artificial
insemination was used for dog breeding.

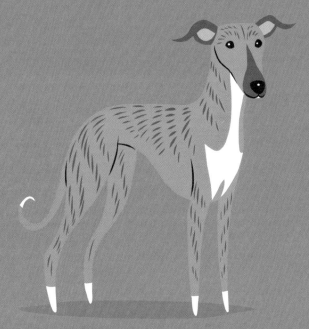

Greyhound

GREAT BRITAIN

Medium-to-large sighthound-type dog, formerly the hunting
and coursing dogs of wealthy men in exclusive clubs. There was
a time when it was illegal for regular people to own a Greyhound!
In the 1900s, Greyhounds' bodies were streamlined to standardize
them as coursing and racing dogs for the gambling industry.
Many ex-racing Greyhounds have been rescued and now live
as companion dogs that run for fun.

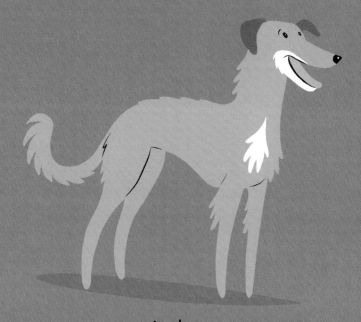

Lurcher

GREAT BRITAIN

Large rough- or smooth-coated sighthound mix bred for the
purposes of hunting or working. Lurchers, as a crossbred type rather
than a recognized breed, vary in appearance and abilities depending
on which breed is crossed with a sighthound or Greyhound. Today's
Lurchers are also companion dogs. In the United Kingdom, two
crossbred sighthound types are called Long Dogs.

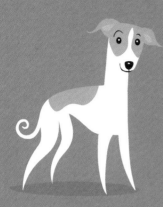

Whippet

Whippie

ENGLAND

Small-to-medium companion dog, originally
bred as the "poor man's Greyhound."

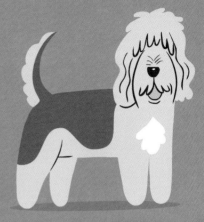

Otterhound

ENGLAND

Large otter-hunting hound. Otter
hunting is now illegal and Otterhounds
are an endangered breed.

Curly-Coated Retriever

ENGLAND

Large gun dog. Tallest and oldest
of the six retriever breeds, related
to the Irish Water Spaniel.

Flat-Coated Retriever

ENGLAND

Medium gun dog. Land and water
retriever with a flat or wavy coat.

Labrador Retriever

Labrador, Lab

NEWFOUNDLAND, ENGLAND

Medium gun dog (retriever), originally employed to find game birds
and fetch them back to hunters with a "soft mouth." Labs are also
popular service/guide dogs, scent-detection dogs, and family dogs.
Despite their name, they are a British breed, descended from the
extinct St. John's Water Dog of pre-Canada Newfoundland.

Clumber Spaniel
ENGLAND
Medium gun dog of nobility
with possible French ancestry. Named
after Clumber Park in Newcastle.

English Springer Spaniel
ENGLAND
Medium gun dog,
flushing dog, and retriever.
The tallest of land spaniels.

English Cocker Spaniel
Cocker, ECS
ENGLAND
Small woodcock-flushing dog and
retriever. Once the same breed as
the Springer Spaniel.

Field Spaniel
ENGLAND
Small show breed developed
in the Midlands from Springers
and Cockers.

Sussex Spaniel
ENGLAND
Small gun dog. Allowed to bark when
locating game, unlike other spaniels.

English Toy Spaniel
King Charles Spaniel
ENGLAND
Small companion dog named
after King Charles II.

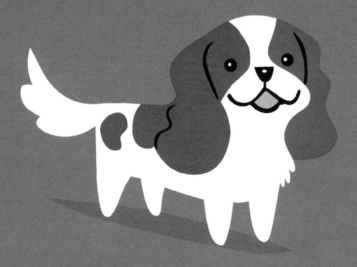

Cavalier King Charles Spaniel

Cavalier

ENGLAND

Small companion dog (not a hunting spaniel) that was
once a royal lap dog. Cavaliers have four coat color varieties:
Blenheim (as pictured), Ruby, Black and Tan, and Tricolor. The
Cavalier diverged into a separate breed from the English Toy Spaniel
after a 1926 competition to create an English Toy Spaniel with
a longer face and flatter skull that would resemble the dogs in
a seventeenth-century Van Dyck painting.

English Pointer
Pointer
ENGLAND
Medium gun dog (pointing dog)
and the Westminster Kennel Club
Show emblem dog.

English Setter
ENGLAND
Medium gun dog (pointing dog) with
different lineages: Laveracks (show),
Llewellin (field), and Ryman (hunting).

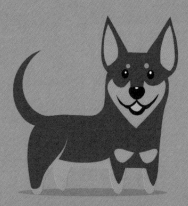

Lancashire Heeler
Ormskirk Heeler, Lankie
ENGLAND
Small herding dog from the Ormskirk region,
also used to drive cattle to markets.

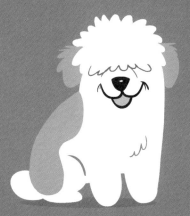

Old English Sheepdog
ENGLAND
Medium bob-tailed herding dog,
before becoming a show dog,
from southwest England.

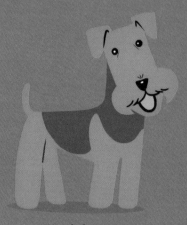

Airedale Terrier

ADT

ENGLAND

Medium hunting and farm dog.
The largest of the British terriers,
nicknamed "King of Terriers."

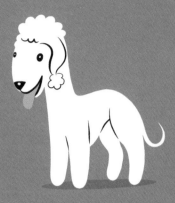

Bedlington Terrier

Rothbury Terrier

ENGLAND

Small companion and show dog
descended from Northumberland
landrace terriers.

Jack Russell Terrier

Jack Russell, JRT

ENGLAND

Small companion/working
terrier with many varieties, created
by parson Jack Russell.

Parson Russell Terrier

ENGLAND

Small terrier that looks like a longer-legged
Jack Russell Terrier. They used to hunt with
Foxhounds and were called Jack Russell
Terriers in the United States before 2003.

Patterdale Terrier
ENGLAND
Small terrier. A working type from
northern England, first recognized as
a breed in the United States (UKC).

Lakeland Terrier
Lakie
ENGLAND
Small companion dog developed from
Lake District landrace Fell Terriers.

Lucas Terrier
ENGLAND, SCOTLAND
Small companion terrier developed by
crossing Sealyhams and Norfolk Terriers.
The Sporting Lucas Terrier is a lineage
developed in Scotland.

Norwich Terrier
ENGLAND
Small prick-eared ratting dog
from Cambridge.

Norfolk Terrier
ENGLAND
Small drop-eared variety of
the Norwich Terrier that became
their own breed in 1979.

Yorkshire Terrier
Yorkie
ENGLAND
Small longhaired companion dog
developed using many breeds.

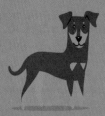

Manchester Terrier
ENGLAND

Small rat-pit contestant and pest-control dog; a reconstructed breed after nearly going extinct in the 1950s.

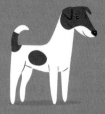

Smooth Fox Terrier
Foxy
ENGLAND

Small show dog derived from the Wire Fox Terrier that became their own breed in the United States in 1985.

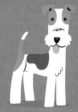

Wire Fox Terrier
Foxy
ENGLAND

Small relation to the Welsh Terrier that has won more Best in Shows than any other breed at the Westminster Kennel Club show.

Bullmastiff
ENGLAND

Large gamekeeper's guard dog descended from the Mastiff and early Bulldogs.

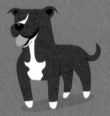

Staffordshire Bull Terrier
Stafford, Staffy
ENGLAND

Medium show and companion dog created from fighting dogs.

English Bulldog
Bulldog
ENGLAND

Medium companion dog, descendant of bullbaiting dogs, and the national dog of England.

Bull Terrier

EBT

ENGLAND

Medium companion dog that was once a dog-fighting dog,
redesigned by James Hinks to have a distinct "egg-shaped"
head and a "cleaner appearance." Their ancestry includes the
Pointer and the (extinct) English White Terrier. The Miniature
Bull Terrier is a separate, smaller breed.

Golden Retriever

Golden

ENGLAND, SCOTLAND

Medium gun dog, assistance dog, scent-detection dog, and popular family dog. Every five years, hundreds of Goldens (and their humans) travel from all around the world to meet up outside Guisachan Estate in the Scottish Highlands to celebrate where Lord Tweedmouth first developed the breed. Back then they were called "Yellow Retrievers."

Gordon Setter

SCOTLAND

Large black-and-tan gun dog
(pointing dog) developed by Alexander,
Duke of Gordon.

Shetland Sheepdog

Sheltie

SCOTLAND

Small herding and sports dog with
Northern European Spitz ancestry.

Bearded Collie

Beardie

SCOTLAND

Medium longhaired herding dog with a
barking and bouncing style in the field.

Scottish Deerhound

Deerie

ENGLAND

Giant Greyhound-type dog, a reconstructed
breed and tribute to the sixteenth-century
hunting dogs of Highland Chieftains.

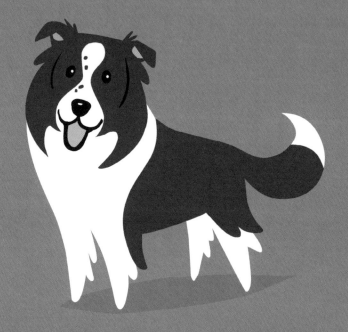

Border Collie

SCOTLAND

Medium herding dog, sports dog, companion dog, and dog trainers'
dog descended from landrace Collies. Working lineages have a distinct
strong-eye (hard-staring), low-to-the-ground style of working with sheep
that they have been selectively bred for. Famous Border Collies that
demonstrate how brilliant dogs are when learning through play sessions
and positive reinforcement: Chaser the Border Collie and Emily Larlham's
Guinness World Record–breaking dogs, Wish and Halo.

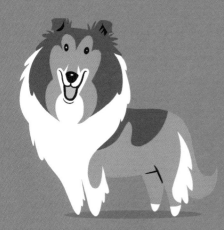

Rough Collie
SCOTLAND
Medium-to-large longhaired show
dog developed from landrace Collies.
Made famous by Lassie.

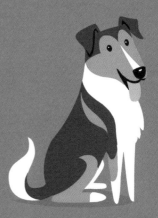

Smooth Collie
Smoothie
SCOTLAND
Medium herding and sports dog
that is the same breed as the Rough
Collie in North America.

Border Terrier
LBD (Little Brown Dog)
SCOTLAND
Small hunting and farm terrier
developed from landrace Fell Terriers,
the oldest of terrier breeds.

Dandie Dinmont Terrier
SCOTLAND
Small companion and show dog related
to the Bedlington Terrier. Named after
a fictional character in the novel *Guy
Mannering* by Sir Walter Scott.

Skye Terrier
SCOTLAND
Small companion and show breed, or
the name of working landrace terriers (two
different lineages with the same name).

Scottish Terrier
Scotch Terrier, Scottie, Diehard
SCOTLAND
Small companion and show terrier
developed in England and redesigned
by Scottish fanciers.

West Highland White Terrier
Westie
SCOTLAND
Small white companion terrier,
once a variety of the Cairn Terrier.

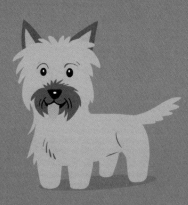

Cairn Terrier
SCOTLAND
Small terrier descended from landrace
terriers, bred to flush small game and vermin
out of rock piles known as cairns.

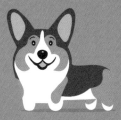

Pembroke Welsh Corgi
Pembi
WALES
Small bob-tailed herding, sports, and companion dog. The favorite breed of Queen Elizabeth II.

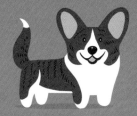

Cardigan Welsh Corgi
Cardi
WALES
Small foxbrush-tailed herding and sports dog that was once the same breed as the Pembroke Corgi.

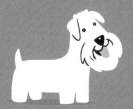

Sealyham Terrier
Daeargi Sealyham
WALES
Small white terrier and companion dog created in Sealyham Hall.

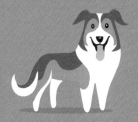

Welsh Sheepdog
Ci Defaid Cymreig
WALES
Medium landrace type of herding dog with variable looks.

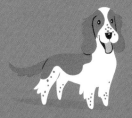

Welsh Springer Spaniel
Llamgi Cymru, Welshie
WALES
Medium flushing dog once the same breed as the English Springer Spaniel.

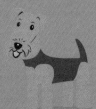

Welsh Terrier
Daeargi Cymreig
WALES
Small black-and-tan companion dog once used for hunting fox, otter, and badger.

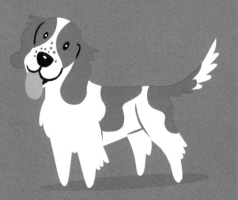

Irish Red and White Setter

An Sotar Rua agus Bán, IRWS

IRELAND

Medium-to-large pointing dog, progenitor
of the Irish Red Setter. Nearly went extinct
during World War II.

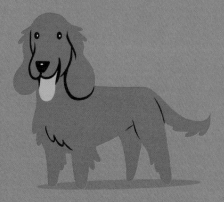

Irish Red Setter

Irish Setter, Sotar Rua

IRELAND

Medium-to-large pointing dog once a variety
of the Irish Red and White Setter.

Irish Water Spaniel

An Spáinnéar Uisce, IWS

IRELAND

Medium curly-coated waterfowl
retriever with a distinct "rat tail"
and the nickname "bog dog."

Kerry Beagle

An Pocadán Ciarraíoch

IRELAND

Small-to-medium pack-hunting hound
that played a role in developing some
Coonhound breeds (United States).

Irish Wolfhound

Cú Faoil

IRELAND

Giant rough-coated dog that resembles an ancient and extinct Gaelic
wolf-hunting dog. The modern form of the breed was reconstructed in 1862
by Captain G. A. Gram through crossbreeding Scottish Deerhounds, Russian
Wolfhounds, and Mastiffs. Irish Wolfhounds of today live as companion dogs
and are a symbol of Irish culture and its Celtic past. At more than 32 inches
tall, the Irish Wolfhound is the tallest recognized purebred dog.

Glen of Imaal Terrier

Brocaire Uí Mháil, Glennie,
Wicklow Terrier

IRELAND

Small companion dog descended from
farm terriers. A reconstructed breed.

Irish Terrier

Brocaire Rua

IRELAND

Small red terrier. Note: The Irish Terrier Club
was the first breed club to ban ear cropping.

Kerry Blue Terrier

An Brocaire Gorm

IRELAND

Medium terrier from County Kerry with a
distinctive blue coat. Ireland's national dog.

Soft Coated Wheaten Terrier

Wheaten, An Brocaire Buí

IRELAND

Medium terrier. Companion
and multipurpose farm dog.

Northern Inuit Dog

Different lineages: Tamaskan, Utonagan,
British Timber Dog

ENGLAND, IRELAND, FINLAND, UNITED STATES

Large companion dog created in the 1980s to look like
wolves by crossbreeding Alaskan Malamutes, German Shepherds,
and Siberian Huskies. Some of these dogs played dire wolves in
the *Game of Thrones* series. The Tamaskan lineage is recognized
by the American Rare Breed Association.

Icelandic Sheepdog

Íslenskur Fjárhundur, Icie

ICELAND

Small Spitz-type companion dog, once a farm dog that herded sheep and ponies. Icelandic Sheepdogs are believed to have arrived in Iceland with the first Viking settlers in 800 AD and are genetically related to the Norwegian Buhund and Swedish Vallhund. The breed nearly went extinct in the 1950s and was revived by Iceland enthusiast Sir Mark Watson.

Broholmer
Danish Mastiff
DENMARK
Large companion and guard dog developed by Count Sehested of Broholm for stag hunting. A reconstructed breed.

Danish Spitz
Dansk Spids
DENMARK
Small Spitz-type companion dog. A reconstructed breed related to the Pomeranian.

Old Danish Pointer
Gammel Dansk Hönsehund
DENMARK
Medium pointing dog descended from Spanish Pointers and Bloodhounds.

Norwegian Elkhound
Norsk Elghund
NORWAY
Medium gray-coated Spitz-type companion dog descended from elk-hunting dogs.

Norwegian Lundehund

Norsk Lundehund

NORWAY

Small Spitz-type companion dog with six toes, a hyperflexible body, and the ability to fold their ears forward or backward. Lundehund dogs were bred specifically for hunting puffins on coastal cliffs. Puffins are now a protected species, and the very small and inbred Lundehund population is in the process of being saved from extinction by being crossed with other Nordic Spitz breeds. The Lundehund is considered a Norwegian national treasure.

Black Norwegian Elkhound
Norsk Elghund Sort
NORWAY
Black-coated variety of
the Norwegian Elkhound.

Norwegian Buhund
Norsk Buhund, Bu
NORWAY
Small Spitz-type farm dog
associated with the Vikings. Today,
they are also hearing-assistance dogs.

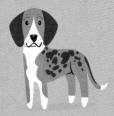

Dunker
Norwegian Hound
NORWAY
Medium rabbit-hunting scenthound with
a merle coat (see page 23). Named after
their creator, Captain W. C. Dunker.

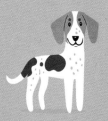

Haldenstøver
Halden Hound
NORWAY
Medium scenthound and one of
Norway's three hare-hound breeds.

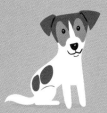

Danish-Swedish Farmdog
DSF, Dansk-Svensk Gårdshund
DENMARK, SWEDEN
Small companion and multipurpose
farm dog related to the Pinscher.

Swedish Vallhund
Västgötaspets
SWEDEN
Small Spitz-type herding and
multipurpose farm dog believed
to be the ancestor of the Corgi.

Swedish Lapphund

Svensk Lapphund

SWEDEN

Small black-coated Spitz-type companion dog descended from
landrace dogs of the Indigenous Sámi people. They are bred to
herd and guard domesticated reindeer in what is now Norway,
Sweden, Finland, and northeastern Russia. The Swedish Lapphund
is related to the Finnish Lapphund and Lapponian Herder.

Norrbottenspets

Norrbottenspitz, Pohjanpystykorva

SWEDEN, FINLAND

Small Spitz-type companion dog
that is closely related to the Finnish
Spitz. A reconstructed breed.

Jämthund

Swedish Elkhound

SWEDEN

Medium-to-large elk-hunting
Spitz of the Jämtland region and
Sweden's national dog.

Hälleforshund

Hällefors Elkhound

SWEDEN

Medium companion and
deer-hunting dog.

Smålandsstövare

Smaland Hound

SWEDEN

Small-to-medium
scenthound with a natural bob tail.
A reconstructed breed.

Eurohound

Eurodog, Scandinavian Hound

SCANDINAVIA

Medium competitive sled-racing dog
created by crossing Alaskan Huskies
with German Shorthaired Pointers.

Drever

Swedish Dachsbracke

SWEDEN

Small short-legged scenthound developed
for hunting purposes.

Gotlandsstövare

Gotland Hound

SWEDEN

Medium scenthound native to
Gotland that hunts fox and hare.

Hamiltonstövare

Hamilton Hound, Hammie

SWEDEN

Medium scenthound named
after A. P. Hamilton, founder of
the Swedish Kennel Club.

Schillerstövare

Schiller Hound, Schiller Bracke

SWEDEN, GERMANY

Medium hunting scenthound with
Swiss Hound and Harrier ancestry.

Lapponian Herder

Lapinporokoira

FINLAND

Medium reindeer-herding
dog of the Sámi people.

Finnish Spitz

Suomenpystykorva, Finkie

FINLAND, RUSSIA

Small hunting dog developed from landrace Spitzes, bred to bark-point when locating game birds. Finnish Spitzes are so valued for their barking that they are entered into barking competitions and said to be able to bark up to 160 times per minute. When Karelia was annexed by the USSR, the breed was split into two lineages and became the Karelo-Finnish Laika in Russia. In 2006, Russia and Finland agreed to recombine both breeds into one, following the Finnish standards. The Finnish Spitz is Finland's national dog.

Finnish Lapphund

Suomenlapinkoira, Lappie

FINLAND

Medium companion dog descended from Sámi reindeer-herding Spitzes.

Seskar Seal Dog

FINLAND

Medium Spitz-type dog that hunted seals on the Gulf of Finland islands. A breed that is being reconstructed.

Finnish Hound

Suomenajokoira

FINLAND

Medium-to-large scenthound and companion dog. One of Finland's most popular hunting dogs.

Karelian Bear Dog

Karjalankarhukoira

FINLAND, RUSSIA

Medium big-game-hunting Spitz and bark-pointer. In Russia, they are called the Russo-European Laika.

Lithuanian Hound

Lietuvių Skalikas

LITHUANIA

Medium scenthound with Bloodhound ancestry. A reconstructed breed.

Latvian Hound

Latvijas Dzinējsuns

LATVIA

Small hunting dog. A reconstruction of the extinct Kurzeme Hound.

Estonian Hound

Eesti Hagijas, Gontchaja Estonskaja

ESTONIA

Small hunting dog and Estonia's national dog. After the 1940s
Soviet Republic ban on large hunting hounds to protect wildlife,
the creation of short-legged local hunting dogs was required by law.
The Estonian Hound was created by crossbreeding various foreign
scenthounds and local dogs.

Dobermann

Doberman, Doberman Pinscher, Dobie

GERMANY

Medium-to-large dog created by Louis Dobermann, a tax collector and dogcatcher, to be his personal guard dog. In the 1900s, Dobermans became popular as police and military dogs. They are one of several breeds that, traditionally, have had their ears and tails surgically altered for cosmetic purposes and for shows. This is a painful practice that is now illegal in Germany and other countries. Doberman or Doberman Pinscher is the breed's name in North America.

German Pinscher

Deutscher Pinscher

GERMANY

Medium companion and working dog originally called a smooth-haired Schnauzer since they were once born in the same litter and split into different breeds by coat type.

Affenpinscher

GERMANY

Small companion and ratting dog derived from rough-haired Pinschers. *Affenpinscher* means "monkey dog" in German.

Miniature Pinscher

Min Pin, Zwergpinscher

GERMANY

Small companion dog and toy breed with a high-stepping gait. Nicknamed the "King of the Toys."

Standard Schnauzer

Mittelschnauzer

GERMANY

Medium bearded companion and working dog, once a wirehaired variety of Pinscher.

Miniature Schnauzer

Zwergschnauzer

GERMANY

Small Schnauzer from Frankfurt possibly derived from crossing the Affenpinscher, Standard Schnauzer, and Miniature Poodle.

Giant Schnauzer

Riesenschnauzer

GERMANY

Giant black-coated working and companion dog. Originally a cattle driver.

Boxer

Deutscher Boxer

GERMANY

Medium companion dog descended from butchers' dogs and bullbaiting dogs.

Rottweiler

Rottweiler Metzgerhund, Rottie

GERMANY

Large Mastiff-type companion dog descended from Rottweiler cattle-herding dogs.

Hovawart

GERMANY

Large companion dog. A reconstruction of an extinct type of farm dog from the Black Forest region.

Bavarian Mountain Hound

Bayerischer Gebirgsschweißhund

GERMANY

Medium hunting scenthound that specializes in tracking injured big game.

Dachshund

Teckel, Dackel, Weenerdog, Doxie

GERMANY

Small hunting and companion dog created to track and flush badgers. Their short legs are the result of deliberately bred genetic dwarfism. There are nine varieties classified by size (Standard/Teckel, Miniature/ Zwerg, Rabbit/Kaninchen) and coat type. The name Dachshund was first popularized by Queen Victoria and now refers to all dogs bred outside Germany's hunting culture, where a hunting Dachshund is called a Teckel.

Longhaired Dachshund
Langhaardackel
GERMANY
Small longhaired variety of
Dachshund/Teckel.

Wirehaired Dachshund
Rauhaardackel
GERMANY
Small wirehaired or rough-coated
variety of Dachshund/Teckel.

Biewer Terrier
GERMANY
Small companion dog created from
German-bred tricolored Yorkshire Terriers
by breeders Mr. and Mrs. Biewer.

Kromfohrländer
GERMANY
Small companion dog created near the
region of Krom Fohr from the Fox Terrier and
Griffon Vendéen. There are both smooth and
wirehaired varieties.

Great Dane
Deutsche Dogge

GERMANY

Giant companion dog—one of the largest breeds—and originally a guard dog of seventeenth-century nobility. Great Danes have had many different names and are not Danish. Originally, they were called *Englischer Hund* due to their English Mastiff ancestry. The name *Grand Danois* originated with a French naturalist in Denmark. It is only outside of Germany that their name suggests a Danish origin! In their native country, *Deutsche Dogge* means German Mastiff.

German Spitz

Deutsche Spitze

GERMANY

Small Spitz-type watchdog and companion
dog with many size varieties and names,
descended from Nordic Spitzes.

Keeshond

Wolfsspitz, Kees

GERMANY, NETHERLANDS

Medium silver-black German Spitz
developed in Holland. The national
dog of the Netherlands.

Pomeranian

Zwergspitz

GERMANY, POLAND

Small companion variety of German Spitz.
The smallest of the Spitz breeds.

Eurasier

GERMANY

Medium companion dog created from
the Keeshond, Samoyed, and Chow Chow.
Their name comes from their mixed European
Spitz and Asian Spitz ancestry.

American Eskimo Dog

American Spitz, Mittelspitz, Eskie

GERMANY, UNITED STATES

Small companion dog developed from white German Spitzes that accompanied German immigrants to the United States. They were circus dogs in the 1930s–40s and were renamed American Spitzes (instead of German Spitzes) for patriotic reasons during World War II. Note: "American Eskimo" was the name of the original breeding kennel in the United States. At the time, eskimo was a pejorative label for northern Native Americans who were not involved with this breed.

German Shorthaired Pointer

GSP, Deutsch Kurzhaar

GERMANY

Medium-to-large versatile gun dog developed from French, Spanish, and English Pointers. Although Deutsch Kurzhaar and German Shorthaired Pointer are two names for the same breed, they are also the names of two separate genetic lineages that have diverged over time and place due to very different breeding systems in German and non-German hunting cultures. (This is also true of other German versatile gun dog breeds.)

German Roughhaired Pointer
Deutsch Stichelhaar
GERMANY
Medium versatile gun dog.
A reconstructed breed.

German Wirehaired Pointer
Deutsch Drahthaar, GWP
GERMANY
Medium versatile gun dog developed
from German Shorthaired Pointers and
rough-coated hunting dogs.

German Longhaired Pointer
Deutsch Langhaar
GERMANY
Medium brown-coated versatile gun dog.

Pudelpointer
GERMANY
Medium-to-large versatile gun dog created
from crossbreeding Poodles and Pointers.

Large Munsterlander
Großer Münsterländer Vorstehhund
GERMANY
Large versatile gun dog from Münster,
developed from the black-and-white variety
of German Longhaired Pointers.

Small Munsterlander
*Kleiner Münsterländer, Spion,
Heidewachtel*
GERMANY
Medium versatile gun dog with French
and Dutch spaniel ancestry.

Weimaraner
Gray Ghost
GERMANY
Medium-to-large versatile gun dog from
Weimar. There is also a longhaired variety.

German Spaniel
Deutscher Wachtelhund
GERMANY
Small flushing and retrieving dog
bred exclusively for hunters and used
to hunt waterfowl and quail.

German Hound
Deutsche Bracke
GERMANY
Medium scenthound. The merging of
several varieties into one breed in 1900.

Jagdterrier
Deutscher Jagdterrier
GERMANY
Small black-and-tan versatile gun dog
bred exclusively for hunters and used to
hunt foxes, badgers, and wild boar.

German Shepherd Dog

GSD, Alsatian, Deutscher Schäferhund

GERMANY

Large companion and working dog created from Old German Herding Dogs (landrace) by Max Von Stephanitz. The original German Shepherd Dogs were herders and guide dogs before they were co-opted by Nazi German and other regimes for military purposes. The breed was temporarily renamed "Alsatian" in some countries (e.g., the United States and United Kingdom) due to anti-German wartime sentiment. Over time, several variants of German Shepherd Dogs have been developed around the world.

Old German Herding Dog

Altdeutsche Hütehund

GERMANY

Medium landrace herding dog with many regional varieties and names, selectively bred by farmers for their ability to move and protect very large herds of sheep and cows. These rural types predate the German Shepherd Dog breed. In Germany, there are organizations working to preserve these dogs' traditional roles and genetic diversity. Pictured here is one variety: the highly endangered Cow Dog (Kuhund) of Westerwald and Siegerland.

Harz Fox
Harzer Fuchs
GERMANY
Medium reddish cow-herding dog and
one variety of the Old German Herding
Dog landrace. From the Harz mountains of
northern Germany.

Schafpudel
Sheep-Poodle, Herding Poodle
GERMANY
Medium shaggy variety of the Old German
Herding Dog landrace. Not to be confused
with a Sheepadoodle, which is a modern
crossbreed pet dog.

Old German Tiger
Altdeutscher Tiger
GERMANY
Medium merle-coated variety of the Old
German Herding Dog landrace from southern
Germany. Related to the Australian Shepherd
and Koolie.

Strobel
South Old German Shepherd
GERMANY
Medium curly-coated variety of the Old
German Herding Dog landrace from Baden-
Württemberg and Bavaria.

Leonberger

Leo

GERMANY

Large companion dog whose ancestors were herding and draft
dogs created from crossing Landseers and Saint Bernards.
Named by the 1830s mayor of Leonberg. Leonbergers have
webbed feet like Newfoundlands and other water dogs. The
breed was nearly lost to extinction during both World Wars but
today are water rescue dogs and family pets.

Drentsche Patrijshond
Dutch Partridge Dog
NETHERLANDS
Medium farm dog, companion dog, and versatile gun dog that originally came from Spain to the province of Drenthe in the sixteenth century.

Dutch Smoushond
Hollandse Smoushond
NETHERLANDS
Small companion dog. Reconstruction of a nineteenth-century yellow Schnauzer.

Stabyhoun
Stabijhoun, Friese Stabij
NETHERLANDS
Medium versatile gun dog and companion dog from Friesland. Considered a Dutch national treasure.

Wetterhoun
Frisian Water Dog
NETHERLANDS
Medium gun dog (water retriever) descended from Romani dogs and local Frisian dogs.

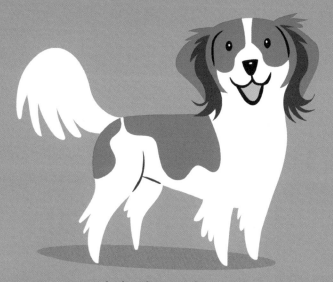

Nederlandse Kooikerhondje

Kooikerhondje, Kooiker, Dutch Decoy Dog

NETHERLANDS

Small spaniel originally bred as a duck-decoy dog. Their job was to play near the water's edge and, by waving their tails, lure curious ducks into hunters' traps. This method of duck-hunting may have influenced the development of the Nova Scotia Duck Tolling Retriever. Kooikerhondje dogs were saved from extinction by the Baronesse van Hardenbroek van Ammerstol and became a companion breed after World War II.

Dutch Shepherd

Hollandse Herdershond, Dutchie

NETHERLANDS

Medium companion dog and police dog descended from rural herding dogs. There are smooth-haired, longhaired, and rough-haired varieties.

Schapendoes

Dutch Sheepdog

NETHERLANDS

Medium companion, sports, and herding dog. A reconstructed breed after near extinction during World War II.

Saarloos Wolfdog

Saarlooswolfhond

NETHERLANDS

Large companion dog created by Leendert Saarloos by crossbreeding German Shepherd Dogs with gray wolves.

Markiesje

Hollandse Tulphond, Dutch Tulip Dog

NETHERLANDS

Small companion dog that resembles a type of black dog seen in seventeenth-century paintings.

Brussels Griffon

Griffon Bruxellois, Griff, Griffie

BELGIUM

Small short-snouted companion dog with King Charles Spaniels and Pugs in their ancestry. The early Brussels Griffons were popular with the rich and famous, e.g., Queen Marie Henrietta of Belgium. In the AKC (United States), Brussels Griffons are one breed with three varieties, but in Europe, these are three separate breeds. The Griffon Bruxellois (pictured here) has a reddish rough-haired coat.

Griffon Belge
Brussels Griffon
BELGIUM
Black rough-coated variety
of Brussels Griffon.

Petit Brabançon
Brussels Griffon
BELGIUM
Smooth-coated variety
of Brussels Griffon.

Schipperke
BELGIUM
Small black Spitz-type companion dog
descended from sheepdogs and cobblers'
dogs in Brussels.

Bouvier des Ardennes
Ardennes Cattle Dog
BELGIUM
Medium working dog developed
from Ardennes cow-herding dogs.

Bouvier des Flandres
Flanders Cattle Dog
BELGIUM
Large draft dog and military working dog
descended from Flanders farm dogs.

Tervuren
*Belgian Shepherd,
Chien de Berger Belge, Terv*
BELGIUM
Medium longhaired "charred fawn" color
variety of the Belgian Shepherd.

Malinois
*Belgian Shepherd,
Chien de Berger Belge*
BELGIUM
Medium shorthaired variety of the Belgian
Shepherd. A popular dog for bite sports.

Laekenois
*Belgian Shepherd,
Chien de Berger Belge*
BELGIUM
Medium rough-haired variety of the Belgian
Shepherd. The rarest of the breed.

Groenendael

Belgian Sheepdog, Belgian Shepherd, Chien de Berger Belge, Groen

BELGIUM

In Belgium, there are four varieties of the same Belgian Shepherd breed, named for coat type and color: Tervuren; Malinois; Laekenois; and the black, longhaired Groenendael (pictured here). Medium Belgian Shepherds have had many roles: herding dogs, guide/assistance dogs, scent-detection dogs, military dogs, search-and-rescue dogs, and companion dogs. In the United States (AKC), the four varieties are recognized as four different breeds, and the name Belgian Sheepdog refers to the Groenendael type.

Bloodhound

Sleuth Hound, Chien de Saint-Hubert

BELGIUM, FRANCE, UNITED KINGDOM

Large scenthound with double the scent receptors in their nose compared
to other breeds. Bred for their ability to follow the scent of wounded game
or people over long distances and for many days. The first Chien de Saint-Hubert
dogs were bred by the monks of Saint Hubert Abbey, but modern Bloodhounds
are more likely to have come from medieval British lineages. Today's Bloodhounds
still use their noses professionally and in competitive "mantrailing" sports.

Braque Français
French Pointing Dog
FRANCE
Medium gun dog from southern France. Braque Français have been standardized into two types that are recognized as two separate breeds in France. The smaller and faster-running Pyrenean type (Type Pyrénées) is more common than the larger and old-style Gascony type (Type Gascogne).

Braque d'Auvergne

Auvergne Pointing Dog

FRANCE

Medium-to-large black-and-white versatile
gun dog from the Cantal region.

Braque du Bourbonnais

Bourbonnais Pointing Dog

FRANCE

Medium versatile gun dog. Reconstructed
in the 1970s after extinction.

Braque de l'Ariège

Ariege Pointing Dog

FRANCE

Large pointing dog from Ariege with
Bracco Italiano looks and ancestry.
A reconstructed breed.

Braque Saint-Germain

Saint-Germain Pointing Dog

FRANCE

Medium-to-large orange-and-white
pointing dog, bred for hunting in the fields,
woodlands, and marshlands.

Poodle

Caniche, Pudel, Standard Poodle, SPOO

FRANCE, GERMANY

Distinctive curly-coated companion dog developed from the Barbet and other water dogs for waterfowl retrieving. There are standard, medium, miniature, and toy size varieties. Poodles are best known for the variety of hairstyles that make them famous in popular media. For the show ring, the Continental clip (pictured here) is the most popular required style. Popular casual styles are the Sporting clip (United Kingdom) and Teddy Bear clip (Japan); see page 23. The Poodle is France's national breed.

Bichon Frise
Bichon Tenerife
FRANCE, BELGIUM, SPAIN
Small white Bichon-type companion dog.
A favorite of French royalty during the
Renaissance. Related to Poodle-type dogs.

Löwchen
Petit Chien Lion
FRANCE, UNITED KINGDOM
Small companion dog seen in seventeenth-
century paintings with a Lion cut (pictured
here) that is the show standard.

Barbet
French Water Dog
FRANCE
Medium-to-large waterfowl-flushing and
retrieving dog related to the Poodle.

Picardy Spaniel
Epagneul Picard
FRANCE
Medium gun dog bred for their weather-
resistant coats. A reconstructed breed.

Blue Picardy Spaniel
Epagneul Bleu de Picardie
FRANCE
Medium blue-gray gun dog developed
from Picardy Spaniels and English Setters.

French Spaniel
Epagneul Français
FRANCE, CANADA
Medium gun dog popular with hunters in
Quebec. Also known as the Canadian Setter.

Saint Usuge Spaniel
Epagneul de Saint-Usuge
FRANCE
Small gun dog from the Bresse region.
A breed that is being reconstructed.

Pont-Audemer Spaniel
Epagneul de Pont-Audemer
FRANCE
Medium curly-coated pointing and water dog
with possible Irish Water Spaniel ancestry.

Brittany

Epagneul Breton, Breton Spaniel, Brittany Spaniel

FRANCE

Medium bob-tailed versatile gun dog. There are international differences among some breeds, and the Brittany is one example. In the 1930s, Brittanys were imported to the United States and developed to have longer legs, shorter bodies, and a different temperament than the Brittanys in France. There are also different acceptable coat colors between the American and French lineages.

Beauceron
Berger de Beauce
FRANCE
Large herding, protection,
search-and-rescue, and detection dog.
One ancestor of the Dobermann.

Berger Picard
Berger de Picardie, Picardy Shepherd
FRANCE
Medium herding dog from the
Picardy region. A rare breed.

Pyrenean Shepherd
Chien de Berger des Pyrénées, Labrit
FRANCE
Small-to-medium herding dog with two
varieties: rough-faced and smooth-faced.

Briard
Berger de Brie
FRANCE
Large companion dog that used to
be a sheep-herding and military dog.

Pyrenean Mountain Dog

Chien de Montagne des Pyrénées, Patou, Great Pyrenees

FRANCE

Large-to-giant white sheep-guardian dog on the France side of
the Pyrenees Mountains. Studies have found that shepherds who
employed Pyrenean Mountain Dogs reported 90 percent fewer sheep
lost to wolf and bear predators than shepherds who did not employ
dogs. Great Pyrenees is the name of the breed in the United States.

Grand Bleu de Gascogne
Great Gascony Blue
FRANCE
Large scenthound descended from
Bloodhounds and used to develop Bluetick
Coonhounds in the United States.

Dogue de Bordeaux
French Mastiff
FRANCE
Large red-coated Mastiff-type
dog developed to be a guard dog
and companion dog.

Beagle Harrier
FRANCE
Medium scenthound bred to hunt rabbits
and hares in packs. A rare breed
developed to combine the best traits from
both the Beagle and the Harrier.

Ariégeois
Ariege-Hound
FRANCE
Medium coursing scenthound bred
to drive game closer to the hunter.

Chien d'Artois
Artois Hound, Briquet
FRANCE
Medium scenthound bred to
drive game closer to the hunter.
A reconstructed breed.

Porcelaine
Chien de Franche-Comté
FRANCE, SWITZERLAND
Medium scenthound with a shiny
coat. A reconstructed breed.

French Bulldog

Frenchie, Bouledogue Français

FRANCE, ENGLAND, UNITED STATES

Small companion dog developed from toy bulldogs in England and brought to France by lacemakers during the Industrial Revolution. Early Frenchies had floppy "rose ears"! When the very first French Bulldog Club was established in the United States, upright "bat ears" were written into the breed's standards. In 2023, the French Bulldog dethroned the Labrador Retriever as the United States' most popular purebred dog.

Wirehaired Pointing Griffon

Korthals Griffon, Griffon à Poil dur Korthals, WPG

FRANCE, NETHERLANDS, GERMANY

Medium versatile gun dog developed by Dutchman E. K. Korthals in Germany to be an ideal walking hunter's dog. After Korthals's death, the breed's parent club moved to France. Today, there are different clubs and lineages for different hunting cultures in Europe and the United States. (In Germany, hunting dogs are not permitted to be bred unless they have passed performance and health tests.)

Griffon Vendéen

FRANCE

Medium wirehaired hunting dog.
Comes in grand basset, briquet,
and petit basset sizes.

Griffon Nivernais

FRANCE

Medium scenthound reconstructed
to resemble fourteenth-century hounds.

Griffon Fauve de Bretagne

FRANCE

Medium scenthound and companion
dog from Brittany once used to hunt
wolves. A reconstructed breed.

Basset Bleu de Gascogne

Blue Gascony Basset

FRANCE

Small short-legged variant of the
Grande Bleu de Gascogne. Bred for
hunting rabbits and hare on foot.

Basset Artésien Normand

Norman Artesian Basset

FRANCE

Small scenthound and tracker of
rabbit, hare, and roe deer. One ancestor
of the English Basset Hound.

Basset Fauve de Bretagne

Brittany Basset

FRANCE

Small companion dog and a
variant of the Griffon Fauve de
Bretagne. A reconstructed breed.

Petit Basset Griffon Vendéen

PBGV, Small Vendéen Basset

FRANCE

Small rough-haired, sporty companion dog originally bred for rabbit hunting in the Vendée district of France. "Bassets" are hounds deliberately bred to have short legs, and PBGVs are the short-legged variant of the Griffon Vendéen. In 2023, the Westminster Kennel Club's Best in Show winner was a PBGV named Buddy Holly.

Continental Toy Spaniel

Papillon, Epagneul Nain

FRANCE, BELGIUM

Small longhaired companion dog bred to be noblewomen's lap
dogs many centuries ago. The variety with large upright fringed ears
is called Papillon (French for "butterfly"). The drop-eared variety is
called Phàlene (meaning "moth"). Papillon is the name of the breed
in the United States.

Greater Swiss Mountain Dog

Grosser Schweizer Sennenhund,
Swissy

SWITZERLAND

Large working and companion dog
originally bred to pull carts, guard, and herd.
The largest of the Swiss mountain dogs.

Appenzeller Sennenhund

Appenzeller Mountain Dog,
Appenzell Cattle Dog

SWITZERLAND

Medium working and companion
dog of dairy cattle herders in the
Appenzell region.

Bernese Mountain Dog

Berner Sennenhund, Berner, BMD

SWITZERLAND

Large companion dog—the most popular
of the Swiss mountain dogs—descended from
Bernese farm dogs.

Entlebucher Mountain Dog

Entlebucher Sennenhund

SWITZERLAND

Medium companion and
livestock-herding dog. The smallest of
the Swiss mountain dog breeds.

Saint Bernard

St. Bernhardshund, Alpine Mastiff, Bernhardiner

SWITZERLAND, ITALY

Large-to-giant companion dog and the Swiss national breed.
Saint Bernards were originally bred by Great Saint Bernard Hospice
monks in the seventeenth century for mountain rescue work on the
Italian-Swiss border. Contrary to vintage cartoon depictions, they
never wore barrels of brandy around their necks and were actually
much smaller dogs. The large Saint Bernards of today were
developed from show lines.

Swiss Hound
Schweizer Laufhund
SWITZERLAND
Medium scenthound with four coat
color varieties: Bernese, Jura, Lucerne,
and Schwyz (pictured here).

Small Swiss Hound
Schweizer Niederlaufhund
SWITZERLAND
Small Basset-type scenthound that
also has Bernese, Jura, Lucerne (pictured
here), and Schwyz color varieties.

White Swiss Shepherd Dog
Berger Blanc Suisse
SWITZERLAND, UNITED STATES
Medium-to-large companion dog
developed from white German Shepherd
Dogs imported from the United States.

Continental Bulldog
Conti
SWITZERLAND
Medium companion bulldog created
to have more mobility and fewer health
problems than the English Bulldog.

Alpine Dachsbracke
Alpenländische Dachsbracke
AUSTRIA
Small scenthound for tracking
wounded game including deer, hare,
and fox in the mountains.

Austrian Black and Tan Hound
Brandlbracke, Vieräugl
AUSTRIA
Medium scenthound for hunting large and
small game in the mountains. Has shared
ancestry with Tyrolean and Styrian Hounds.

Tyrolean Hound
Tiroler Bracke
AUSTRIA
Medium scenthound from Tyrol
developed from German and Celtic
hounds in the 1860s.

Styrian Coarse Haired Hound
*Steirische Rauhhaarbracke,
Peitinger Bracke*
AUSTRIA
Medium boar-tracking hound created by
industrialist Karl Peitinger in 1870 for hunting
in rough mountain terrain.

Austrian Pinscher

Österreichischer Pinscher

AUSTRIA

Medium companion and multipurpose farm dog originally created
by a scientist to resemble the ancient *Canis Palustris*, an extinct type of
dog from the marshes. This was done by crossbreeding German Pinschers
and local farm dogs. Austrian Pinschers worked as watchdogs guarding
barns and property, and are known for their long, loud barks.

Polish Lowland Sheepdog

PON, Polski Owczarek Nizinny

POLAND

Small-to-medium companion dog descended from sheep-herding dogs
of Central Asia. PONs are said to be the ancestors of Bearded Collies.
They almost went extinct during World War II but were revived by
veterinarian Dr. Danuta Hryniewicz and her PON, Smok (Polish for
"dragon"), who sired ten litters between 1956 and 1959.

Polish Hound
Ogar Polski
POLAND
Medium scenthound originally bred
by royalty. A reconstructed breed.

Polish Hunting Dog
Gończy Polski
POLAND
Small black-and-tan variety of Polish
Hound. Reconstructed in the 1980s by
Colonel Józef Pawłusiewicz.

Polish Hunting Spaniel
Polski Spaniel Myśliwski
POLAND
Small-to-medium flushing dog. A
reconstruction of a pre-Victorian nineteenth-
century hunting spaniel.

Tatra Shepherd Dog
*Polski Owczarek Podhalanski,
Polish Tatra Sheepdog*
POLAND
Large white livestock guardian
dog in the Tatra Mountains. May
be related to the Cuvac.

Chart Polski

Polish Greyhound, Polish Sighthound

POLAND

Large hunting sighthound of uncertain origin that went extinct
during World War II. The breed was reconstructed in the 1970s using
dogs from Ukraine and Russia, and standardized with reference
to dog images in nineteenth-century paintings. Chart Polski are now
companion dogs that participate in dog sports like lure coursing.

Bohemian Shepherd

Chodský Pes

CZECH REPUBLIC

Medium border-patrol dog bred by
the Chodové people in the kingdom
of Bohemia. A reconstructed breed for
search-and-rescue and herding.

Bohemian Spotted Dog

*Český Strakatý Pes, Horák's
Laboratory Dog, Czech Spotted Dog*

CZECH REPUBLIC

Medium companion dog originally bred
for laboratory research in the 1950s.

Český Fousek

Czech Wirehaired Pointing Griffon

CZECH REPUBLIC, SLOVAKIA

Medium versatile gun dog with
different lineages. Believed to be closely
related to the Stichelhaar.

Czech Mountain Dog

Český Horský Pes

CZECH REPUBLIC

Medium-to-large companion dog
created for mountain sports including
sled-dog racing and skijoring.

Czechoslovakian Vlciak

Československý Vlciak, Czechoslovakian Wolfdog

CZECH REPUBLIC, SLOVAKIA

Large dog resulting from a 1955 crossbreeding experiment in the Czechoslovakian military kennels using German Shepherd Dogs and Carpathian Gray Wolves to create an ideal working dog. Vlciak have since been used for police work and search-and-rescue. In 2018, a Vlciak named Chuck played the role of the first prehistoric dog in the film *Alpha*. The popularity of movies featuring "wolves" has led to a demand for wolfdog types as pets and unethical breeding situations that cause many wolf look-alikes to end up in shelters.

Česky Terrier

Czech Terrier, Český Teriér

CZECH REPUBLIC

Small forest hunting dog with Scottish Terrier
and Sealyham Terrier ancestry.

Prague Ratter

Pražský Krysařík

CZECH REPUBLIC, SLOVAKIA

Small companion dog. The shortest
breed in the world.

Slovenský Kopov

Slovakian Hound

SLOVAKIA

Medium scenthound used for boar
tracking and Slovakia's national dog.

Cierny Sery

Slovak Shepherd

SLOVAKIA

Large companion dog descended from
Old German Herding Dogs, Belgian
Shepherds, and Schnauzers.

Slovensky Cuvac

Slovakian Chuvach, Slovenský Čuvač

SLOVAKIA

Large livestock guardian dog related
to the Tatra Shepherd.

Slovakian Wirehaired Pointer

Slovenský Hrubosrstý Stavač,
Slovak Rough-Haired Pointer

SLOVAKIA

Medium-to-large versatile gun dog
descended from the Weimaraner.

Komondor

Hungarian Sheepdog

HUNGARY

Large herding dog with a long corded coat. Descended from the sheepdogs of the nomadic Cuman people.

Kuvasz

HUNGARY

Large guard dog descended from the livestock guardian dogs of the ancient Magyars. A reconstructed breed.

Magyar Agar

Hungarian Greyhound

HUNGARY, TRANSYLVANIA

Large coursing sighthound bred by Magyar nobility for hunting small game.

Mudi

HUNGARY

Small-to-medium herding and sports dog related to the Puli and Pumi.

Puli

HUNGARY

Small-to-medium sheep-herding dog with a corded coat that's smaller than the Komondor and Bergamasco. In the early 1900s, attempts were made to save the breed from extinction, and various sizes of Pulik ("Pulik" is the plural form of "Puli") were exhibited at the Budapest Zoo as part of a breeding program. As is the case with almost all European breeds, the Puli breed had to be revived after World War II, and they have since become popular companion dogs in other countries.

Pumi

HUNGARY

Small curly-coated terrier-type of companion
and herding dog related to the Puli.

Sinka

HUNGARY

Small-to-medium herding and companion
dog descended from the Mudi, Puli, Pumi,
and other herding dogs. The youngest
Hungarian breed.

Transylvanian Hound

Erdélyi Kopó

HUNGARY

Medium versatile gun dog with tall and
short varieties. A reconstructed breed.

Wirehaired Vizsla

Drótzőrű Magyar Vizsla

HUNGARY

Medium versatile gun dog created from
German Wirehaired Pointers to be better
adapted to cold and wet regions.

Vizsla

Rővidszőrű Magyar Vizsla, Hungarian Shorthaired Pointer

HUNGARY

Medium versatile gun dog (pointing dog) and Hungary's national dog. The breed was reconstructed after World War II using dogs that met national standards of appearance and hunting ability. Like many other gun dog breeds, the Vizsla has diverged into separate hunting and companion/show lineages.

Karakachan

BULGARIA

Large livestock guardian dog and landrace bred by nomadic Greek shepherds (Karakachans) to protect goats and sheep from dangerous predators on mountainous terrain. Under USSR rule after World War II, farms became nationalized and Karakachan dogs were killed for their pelts, though they are now protected in conservation programs. They have also been imported to the United States to protect sheep and goats from coyotes. Note: Karakachan dogs are the ancestors of the Bulgarian Shepherd national breed.

Bucovina Shepherd Dog
Ciobănesc Românesc de Bucovina
ROMANIA
Large livestock guardian dog
from northeastern Romania.

Romanian Mioritic Shepherd Dog
Ciobănesc Românesc Mioritic
ROMANIA
Large livestock guardian and companion
dog in the Carpathian Mountains. *Mioară*
is Romanian for "young sheep."

Romanian Raven Shepherd Dog
Ciobănesc Românesc Corb, Corbi
ROMANIA
Large black-coated watchdog and
cattle dog from the Meridional Carpathian
and Subcarpathian area.

Romanian Carpathian Shepherd
Ciobănesc Românesc Carpatin
ROMANIA
Large livestock guardian dog in
the Carpathian Mountains.

Šarplaninac

Illyrian Shepherd Dog

MACEDONIA, SERBIA, ALBANIA

Large livestock guardian dog named after the Šhar Mountains. The national dog of Macedonia.

Karaman

Macedonian Shepherd Dog

MACEDONIA

Large black-coated variety of the Šarplaninac.

Karst Shepherd Dog

Kraški Ovčar, Kraševec

SLOVENIA

Large livestock guardian dog from the Karst Plateau. Once the same breed as the Šarplaninac.

Tornjak

Bosnian and Herzegovinian–Croatian Shepherd Dog

BOSNIA AND HERZEGOVINA, CROATIA

Large livestock guardian dog originally from the Dinaric Alps. A reconstructed breed.

Barak
Bosanski Oštrodlaki Gonič-Barak,
Bosnian Broken-Haired Hound
BOSNIA AND HERZEGOVINA
Medium scenthound once known as the
Illyrian Hound. *Barak* is Turkish for "shaggy."

Serbian Hound
Srpski Gonič
SERBIA
Medium scenthound native
to the Balkan region.

Serbian Tricolor Hound
Srpski Trobojni Gonič
SERBIA
Medium scenthound previously a
variety of the Serbian Hound.

Posavac Hound
Posavski Gonič
CROATIA
Medium scenthound from the
Sava Valley.

Istrian Short-Haired Hound
Istarski Kratkodlaki Gonič
CROATIA
Medium scenthound descended from
an old type of hound. After the breakup of
Yugoslavia, there was a nine-year battle to
establish their country of origin.

Istrian Coarse-Haired Hound
Istarski Oštrodlaki Gonič
CROATIA
Medium rough-haired scenthound derived
from the Istrian Short-Haired Hound. Both
breeds became officially recognized by
the FCI as Croatian breeds.

Croatian Sheepdog
Hrvatski Ovčar
CROATIA
Medium black, wavy, or curly-coated
companion and herding dog.

Small Međimurje Dog
Mali Međimurski Pas, MEDI
CROATIA
Small companion dog developed from
the farm dogs of northwestern Croatia.

Dalmatian

Dalmatinski Pas, Dal

CROATIA, ENGLAND

Medium companion and hunting dog with a unique spotted coat.
The Dalmatian's origin is uncertain. Although officially Dalmatians are
from Croatia and similarly spotted dogs have been seen in fourteenth-
century Croatian paintings, the breed is best known for its various
roles in eighteenth-century England, including being coach dogs,
stable-guarding dogs, fire-brigade mascots, and hunting dogs. In
the twentieth century, they were popularized as pet dogs in the Walt
Disney animated movie *One Hundred and One Dalmatians*.

Muffin (TURKEY)

Indy (GREECE)

Nora (BULGARIA)

European Village Dogs

Free-ranging street dogs and adopted companion dogs of all sizes, with mixed-breed and indigenous ancestry, European village dogs are diverse in their appearances. Thick-coated Spitz types are likely to have come from the north, but most European village dogs live in Central, Southern, and Eastern Europe.

Tempo (SPAIN)

Happy (ROMANIA)

Malchik (RUSSIA)

Baxter (ROMANIA)

Snok (RUSSIA)

Podenco Andaluz

Andalusian Podenco, Andalusian Hound

ANDALUSIA, SPAIN

Small-to-medium primitive-type dog bred for hunting small game, with three sizes and three coat types (hard-coated, silky-coated, and short-coated). Podenco-type dogs—with their slender, long-legged bodies and large upright ears—are also known as warren hounds (for rabbit hunting) and are indigenous to the Iberian region. The Podenco Andaluz is one of four Podencos recognized by the Spanish Kennel Club.

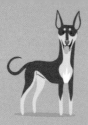

Podenco Orito

ANDALUSIA, SPAIN

Medium rabbit-hunting hound. The chocolate-tan variety of Podenco Andaluz.

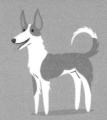

Podenco Galego

Galician Podenco

GALICIA, SPAIN

Medium-to-large rabbit-hunting hound.

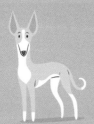

Ibizan Hound

Podenco Ibicenco, Ibizan Podenco, Ca Eivissenc

BALEARIC ISLANDS, SPAIN

Medium rabbit-hunting hound from the isle of Ibiza. Closely related to the Pharoah Hound.

Podenco Campanero

BALEARIC ISLANDS, SPAIN

Large white shaggy rabbit-hunting hound from Ibiza.

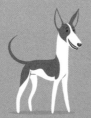

Podenco Canario

Canary Island Podenco, Canarian Warren Hound

CANARY ISLANDS, SPAIN

Small-to-medium rabbit-hunting hound related to the Cirneco dell'Etna.

Podenco Valenciano

Xarnego Valenciano

VALENCIA, SPAIN

Medium companion and rabbit-hunting dog with a smooth, rough, or silky coat.

Maneto
ANDALUSIA, SPAIN
Small short-legged companion and hunting
dog derived from the Podenco Andaluz.

Can Guicho
Quisquelo
GALICIA, SPAIN
Small Spitz-type hunting dog possibly related
to Nordic dogs.

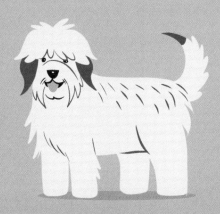

Catalan Sheepdog
*Gos d'Atura Català, Perro de Pastor
Catalàn*
ANDORRA, CATALONIA, SPAIN
Medium herding and guardian dog from the
Catalonian Pyrenees Mountains.

Basque Shepherd
*Euskal Artzain Txakurra, Perro de
Pastor Vasco*
BASQUE COUNTRY, SPAIN
Medium sheep-herding dog with soft and
rough-coat varieties.

Majorca Shepherd Dog

Perro de Pastor Mallorquín, Ca de Bestiar

BALEARIC ISLANDS, SPAIN

Large black-coated shorthaired or longhaired general-purpose farm dog.

Garafian Shepherd

Pastor Garafiano

CANARY ISLANDS, SPAIN

Medium-to-large herding dog native to the island of La Palma. A reconstructed breed.

Carea Leonés

Leonese Sheepdog

CASTILE AND LÉON, SPAIN

Medium herding dog. One ancestor of the Australian Shepherd.

Perro Pastor Altoaragonés

Can de Chira, Aragonese Shepherd Dog

ARAGÓN, SPAIN

Small-to-medium sheep- and cattle-herding dog.

Alano Español

Spanish Bulldog

SPAIN

Medium-to-large Bulldog-type dog whose ancestors were used in the bullfighting ring, in cattle slaughterhouses, and for colonial warfare in the Americas. The breed almost became extinct when they were no longer needed for their original jobs, and they have been revived as companion dogs since the 1990s.

Galician Shepherd

Can de Palleiro, Haystack Dog

GALICIA, SPAIN

Medium shepherd dog. A breed that is being revived and was officially recognized by the Xunta de Galicia in 2001.

Lobito Herreño

Hierran Wolfdog

CANARY ISLANDS, SPAIN

Medium shepherd dog and one of Canary Islands' heritage breeds.

Majorca Mastiff

Ca de Bou, Perro Dogo Mallorquín

BALEARIC ISLANDS, SPAIN

Medium Mastiff-type dog with bullfighting and dogfighting ancestry. A reconstructed breed.

Perro Majorero

Majorero Dog

CANARY ISLANDS, SPAIN

Medium working dog native to the island of Fuerteventura. A reconstructed breed.

Presa Canario

Dog Canario, Canary Dog

CANARY ISLANDS, SPAIN

Large herding and working dog on Gran Canaria and the national dog of Canary Islands. Revived as a companion dog.

Pyrenean Mastiff

Mastín del Pirineo

ARAGÓN, SPAIN

Large-to-giant livestock guardian dog and a landrace. Shares ancestry with the Pyrenean Mountain Dog and Spanish Mastiff.

Spanish Mastiff

Mastín Español

SPAIN

Large-to-giant landrace livestock guardian dog whose job is to
travel with pastoral shepherds. Spanish Mastiffs wear spiked collars
to protect their necks and use deep barks to protect Merino sheep
and cattle from wolves. They are a national symbol of Spain and
have many local working varieties. Outside of Spain, Spanish
Mastiffs are mostly companion and show dogs.

Galgo Español
Spanish Greyhound
SPAIN
Large smooth- and rough-coated sighthound bred for hunting hares. Believed to be related to the English Greyhound.

Majorcan Pointer
Ca Mè Mallorquí
BALEARIC ISLANDS, SPAIN
Medium pointing dog from Majorca and Minorca islands. A reconstructed breed officially recognized in Spain in 2004.

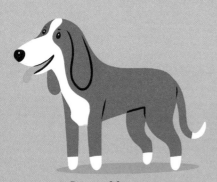

Braco Vasco
Erbi Txakur
BASQUE COUNTRY, SPAIN
Medium scenthound used to hunt wild boar, roe deer, and fox. An endangered breed.

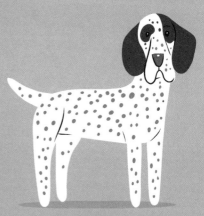

Burgos Pointer
*Perdiguero de Burgos,
Burgalese Pointer*
CASTILE AND LEÓN, SPAIN
Large gun dog that resembles the earliest pointing dogs. A reconstructed breed.

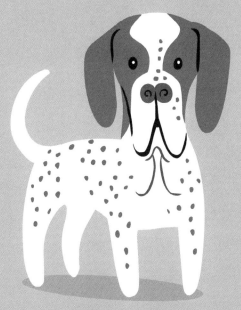

Pachón Navarro

Nafarroako Eper Txakur, Spanish Double-Nosed Pointer

BASQUE COUNTRY, SPAIN

Medium split-nose (bifid) pointing dog descended from fourteenth-century scenthounds and indigenous Mastiffs. Note that not all Pachón Navarro dogs are selectively bred for bifid noses; the bifid nose is a trait that can appear in other breeds, too.

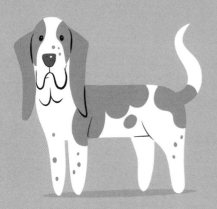

Sabueso Español
Spanish Hound
SPAIN
Medium scenthound used for hunting
small-to-large game from northern Spain.
A reconstructed breed.

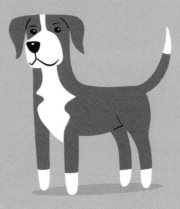

Perdigueiro Galego
Galician Pointer
GALICIA, SPAIN
Medium gun dog (pointing dog) with
Bracco Italiano and Portuguese Pointer
ancestry. A reconstructed breed.

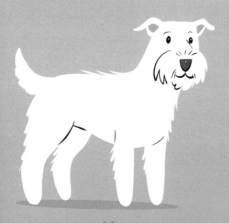

Valdueza
Perro Montero Valdueza
ANDALUSIA, SPAIN
Large white hound for mountainous terrain
that hunts in packs. Created from the rough-
haired Podenco Andaluz.

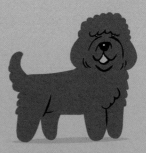

Spanish Water Dog
Perro de Agua Español, SWD
ANDALUSIA, CANTABRIA, SPAIN
Small-to-medium curly-coated sheepdog
and waterfowl-hunting dog with different
sizes according to region.

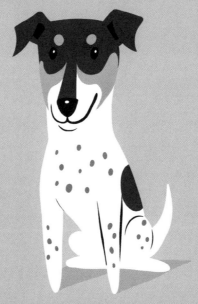

Andalusian Wine-Cellar Rat-Hunting Dog

Ratonero Bodeguero Andaluz

ANDALUSIA, SPAIN

Small terrier whose original job description is in its breed name!
These companion dogs are descended from terriers brought over to
Spain by English wine merchants and crossbred with local dogs.
They eliminated rats and mice in the wineries.

Majorca Ratter

Ratonero Mallorquín, Ca Rater Mallorquí

BALEARIC ISLANDS, SPAIN

Small rat- and rabbit-hunting companion dog related to the Valencian Terrier.

Valencian Terrier

Ratonero Valenciano, Gos Rater Valencià

VALENCIA, SPAIN

Small companion terrier with British terrier ancestry. Recognized by the FCI in 2022.

Rafeiro do Alentejo

Alentejo Mastiff

PORTUGAL

Large livestock guardian dog from the same landrace as the Spanish Mastiff.

Estrela Mountain Dog

Cão da Serra da Estrela, EMD

PORTUGAL

Large livestock guardian dog with a long or short coat. From the Serra da Estrela mountains.

Transmontano Mastiff

Cão de Gado Transmontano

PORTUGAL

Large livestock guardian dog of Trás-os-Montes, employed in the dangerous job of protecting sheep from wolves. As a landrace (related to the Rafeiro do Alentejo), they are well-adapted to the steep mountainous pastures. In 2014, puppies that were once exclusive to this part of Portugal were exported to the United States to be used by Oregon sheep farmers after wolves had killed fifty of their regular dogs.

Portuguese Podengo

Podengo Português, Portuguese Warren Hound

PORTUGAL

Medium-to-large smooth- or wire-coated hunting and companion dog native to the Iberian Peninsula. The Portuguese Podengo has three size varieties: grande for hunting deer and boars, and medio and pequeno for flushing rabbits. They are bred to hunt in packs and have catlike stalking and pouncing movements.

Portuguese Podengo Pequeno

Podengo Português Pequeno

PORTUGAL

Small companion and hunting variety
of the Portuguese Podengo.

Saint Miguel Cattle Dog

*Azores Cattle Dog,
Cão Fila de São Miguel*

AZORES, PORTUGAL

Medium herding dog from
the island of Saint Miguel.

Barbado da Terceira

Terceira Cattle Dog

AZORES, PORTUGAL

Medium herding dog on the
island of Terceira.

Portuguese Sheepdog

Cão da Serra de Aires

PORTUGAL

Medium herding and sports
companion dog nicknamed cão
macaca ("monkey dog").

Castro Laboreiro Dog

*Cão de Castro Laboreiro,
Portuguese Cattle Dog*

PORTUGAL

Medium companion and livestock
guardian dog in the mountains.

Portuguese Pointer

Perdigueiro Português

PORTUGAL

Medium gun dog (pointing dog) and
one ancestor of the English Pointer.

Portuguese Water Dog

Cão de Agua Português, PWD

PORTUGAL

Medium companion dog whose ancestors herded fish into
fishermen's nets and couriered messages between boats. There
are two varieties—the curly-coated and the wavy-haired—and they
can be groomed in two styles: the Retriever clip (as pictured) and
the Lion clip. Portuguese Water Dogs are genetically related to
the Barbet and the Poodle.

Bracco Italiano
Italian Pointing Dog
ITALY
Medium versatile gun dog with a
trotto spinto (flying trot style).

Segugio dell'Appennino
ITALY
Small-to-medium hare-hunting scenthound
that became a distinct breed from other
Italian hounds in 1882.

Segugio Italiano a Pelo Forte
Italian Rough-Haired Segugio
ITALY
Medium rough-haired scenthound used
to hunt hare and wild boar.

Segugio Italiano a Pelo Raso
Italian Short-Haired Segugio
ITALY
Medium smooth-coated scenthound
considered a separate breed from the rough-
haired variety by the Italian Kennel Club.

Spinone Italiano
Italian Coarsehaired Pointer
ITALY
Medium-to-large versatile gun dog
and companion dog with a rough coat.
A reconstructed breed.

Segugio Maremmano
ITALY
Medium scenthound from the
Tuscany region used to hunt hare
and wild boar.

Lagotto Romagnolo
Romagna Water Dog

ITALY

Small-to-medium curly-coated dog descended from duck-retrieving dogs in the Romagna marshlands (*lagotto* means "duck dog"). Lagottos were almost extinct when the marshlands were drained in the nineteenth century and their job description changed to "specialist truffle searchers." However, in countries where there are no truffles, Lagotto Romagnolo dogs are still water retrievers and gun dogs.

Maremma Sheepdog

Maremma-Abruzzese Sheepdog, Cane da Pastore
Maremmano Abruzzese

ITALY

Large white livestock guardian dog used by shepherds to protect
sheep from wolves. The two original types—Abruzzese (heavier) and
Maremmano (lighter)—were unified into one breed in the 1950s.
Maremmas have been exported around the world as working
guardians. In Australia, there are Maremmas protecting a colony
of little penguins from foxes.

Bolognese
ITALY
Small Bichon-type companion dog
and one-time royal pet. They are related
to the Maltese, Coton de Tulear, and
Bichon Frise.

Italian Greyhound
Piccolo Levriero Italiano, Iggy
ITALY
Small companion sighthound
once popular with royalty and nobility.
The smallest of the sighthounds.

Cirneco dell'Etna
Sicilian Greyhound
SICILY, ITALY
Small rabbit-hunting dog
related to the Pharoah Hound and
named after Mount Etna.

Volpino Italiano
ITALY
Small companion Spitz closely related
to the German Spitz. *Volpino* means "little
fox" in Italian. A reconstructed breed.

Pastore della Sila

Sila Shepherd

ITALY

Large livestock guardian dog
used by shepherds in Calabria to protect
goats and cattle from wolves.

Cane Paratore

Cane Toccatore, Italian Wolfdog

ITALY

Medium herding dog from Abruzzo
that may be one ancestor of the German
Shepherd Dog and other herding breeds.

Bergamasco Sheepdog

Cane da Pastore Bergamasco

ITALY

Medium companion, herding, and
guardian dog with a corded coat. Descended
from Italian Alpine sheepdogs and related
to the Briard.

Pastore della
Lessinia e del Lagorai

Shepherd Dog of Lessinia and Lagorai

ITALY

Medium sheep-, cattle-, and horse-herding
dog native to the Triveneto region.

Oropa Shepherd Dog

Cane D'Oropa

ITALY

Medium sheep- and cattle-herding
dog from Piedmont. They are being
preserved from extinction.

Sardinian Shepherd Dog

Cane Fonnesu, Fonni's Dog

SARDINIA, ITALY

Medium working landrace dog
on the island of Sardinia.

Lupo Italiano

ITALY

Large companion dog created
by crossbreeding German Shepherd
Dogs to look wolflike.

Neapolitan Mastiff

Mastino Napoletano

ITALY

Large companion dog with ancient
Roman war dogs and guard dogs as
ancestors. A reconstructed breed.

Cane Corso

Cane Corso Italiano, Italian Mastiff

ITALY

Medium and large Mastiff-type dog whose ancient ancestors were created by crossing Greek dogs with local Roman dogs. Cane Corso dogs are said to have been bodyguards to Roman soldiers, and they guarded rural farmsteads. The breed nearly went extinct in the mid-twentieth century during the World Wars and has been revived as companion and guard dogs.

Pharoah Hound

Kelb Tal-Fenek, KTF

MALTA

Medium, primitive-type companion dog developed from rural
rabbit-hunting hounds. The national dog of Malta. They were so
named in the United Kingdom due to their resemblance to dogs in
ancient Egyptian tomb paintings. The story is that they were brought
to Malta and Gozo thousands of years ago with Phoenician traders.
However, according to DNA studies, the Pharoah Hound is a modern
nineteenth-century creation and not as ancient as they appear.

Maltese
MEDITERRANEAN REGION
Small white silky-haired companion
dog related to the Bichon breeds.

Greek Harehound
Hellenikos Ichnilatis, Gekas
GREECE
Medium black-and-tan scenthound
used to hunt hare and wild boar.

Cretan Hound
Kritikos Lagonikos, Ntopio
CRETE, GREECE
Medium hunting hound
on the island of Crete.

Greek Shepherd Dog
Ellinikós Pimenikós
GREECE
Large livestock guardian dog
closely related to the Šarplaninac.

Kokoni

Small Greek Domestic Dog

GREECE

Small companion dog of all colors and a landrace.
Kokoni means "small dog" in Greek. In 2004, the Kokoni
became developed and recognized as a breed by
the Greek Kennel Club.

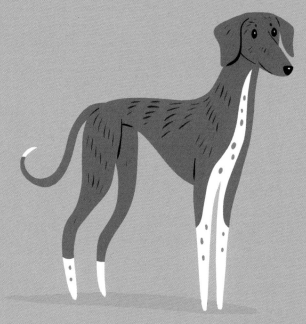

Azawakh

Tuareg Sighthound

SAHEL REGION, SOUTHWEST SAHARA

Large slim smooth-haired sighthound bred by the Tuareg and other nomadic tribes for gazelle hunting and the guarding of livestock and homes. When first imported to Europe for dog shows in the 1970s, Azawakh and Sloughi dogs were confused as the same breed.

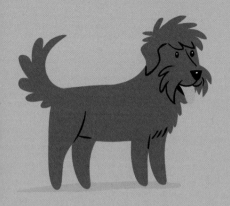

Armant

Ermenti, Egyptian Sheepdog
EGYPT
Medium herding and guard dog
descended from Briards brought to Egypt
by Napoleon's armies.

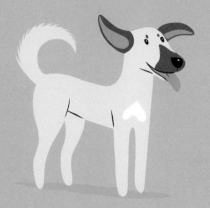

Baladi Dog

Egyptian Street Dog
EGYPT
Medium street dog and adopted
companion dog with diverse looks and
mixed ancestry. The name *Baladi* is the
Bedouin word for "native."

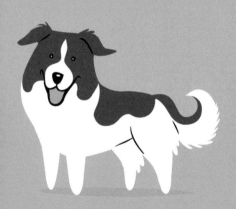

Aïdi

Atlas Mountain Dog, Berber Dog
MOROCCO
Medium livestock guardian dog of the
Berbers. Native to the Atlas Mountains.

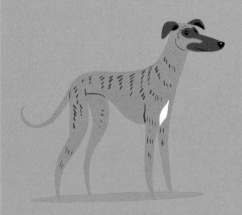

Sloughi

Uskay, Oska, Berber Greyhound
MOROCCO, MAGHREB REGION
Large smooth-haired sighthound of
the Berbers. There are desert and
mountain varieties.

North African Village Dogs

Free-ranging and adopted companion dogs
descended from indigenous dogs.

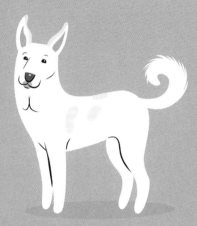

Amal (Baladi Dog; EGYPT)

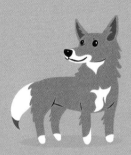

Ruby (MOROCCO)

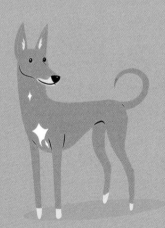

Tala (SUDAN)

Harvey (Baladi Dog; EGYPT)

Basenji
Congo Dog

CONGO BASIN, ZAIRE

Small hunting dog native to the Congo Basin that was imported to the United Kingdom and developed into the Basenji breed. In a few local languages, the name Basenji sounds like a pejorative word that means "savages." Basenjis are a "basal breed," which means their DNA is relatively unmixed with modern European breeds. They are found to have similar traits as the New Guinea Singing Dog. They yodel and chortle instead of bark.

Laobé
West African Village Dog
SENEGAL
Small-to-medium street dog with diverse looks, from sub-Saharan western Africa.

Avuvi
Ghanaian Village/Street Dog
GHANA
Small-to-medium primitive-type dog with diverse looks, descended from the indigenous dogs of the Dahomey Gap region.

Coton de Tulear
MADAGASCAR
Small Bichon-type companion dog with a white cottony coat. Madagascar's national dog.

Boerboel
South African Mastiff
SOUTH AFRICA
Large Mastiff-type dog originally bred to be a farm dog and guard dog by Afrikaner settlers.

Rhodesian Ridgeback

"African Lion Dog," African Lion Hound, Ridgie

SOUTH AFRICA, ZIMBABWE

Large ridge-bearing companion dog that was originally created for big-game hunting, especially of lion. The Rhodesian Ridgeback is the result of European colonists crossbreeding European breeds like Bloodhounds and Great Danes with local ridged Khoisan landrace dogs (now extinct). Their ridge is a genetic mutation that has been selected for, with ridgelessness considered a disqualification. The Rhodesian Ridgeback breed standard was first drafted in Zimbabwe—previously known as Rhodesia—which is where their name comes from.

Africanis

Africanis Nguni, Canis Africanis

SUB-EQUATORIAL AFRICA, KWAZULU-NATAL

Africanis is the umbrella name for the medium landrace dogs or indigenous village dogs of rural southern Africa that are free-ranging community dogs, livestock herders, guardians, and companions with variable looks and many local names, for example, Bantu Dog, Tswana Dog (Botswana), Zulu Dog, Isiqha (a variety with big ears), I-Bantu (floppy ears), I-Twina, and so on. Africanis are valued for their genetic distinctness from township street mutts and are being preserved by the Africanis Society of Southern Africa.

Oso (CENTRAL
AFRICAN REPUBLIC)

Afofie (GHANA)

Sub-Saharan African Village Dogs

Free-ranging and adopted companion dogs descended
from the indigenous dogs of sub-Saharan Africa. They may
or may not also have European breeds in their ancestry.

Shaka (GUINEA)

Naya (KENYA)

Chalo (Africanis; MALAWI)

Chobe (Tswana Dog; BOTSWANA)

Rosie (DJIBOUTI)

Aero (Africanis; BOTSWANA)

Hope (KENYA)

Nandi (Africanis; SOUTH AFRICA)

Nova (SENEGAL)

Kangal Shepherd Dog

Kangal Çoban Köpeği, Karabaş

TURKEY, CENTRAL ASIA

Large livestock guardian dog and one variant of the Turkish Shepherd (Çoban Köpeği) landrace. The Kangal Shepherd Dog is Turkey's national dog, and Kangals have been bred and trained to work as guardians around the world. One example is in Namibia, where the Cheetah Conservation Fund trains Kangals to protect goats from cheetahs and, in doing so, protects cheetahs from being shot by farmers.

Anatolian Shepherd

TURKEY, UNITED STATES

Large livestock guardian and
show dog developed as a breed in the
United States from the same landrace
ancestors as the Kangal.

Akbash

Akbaş Çoban Köpeği

TURKEY

Large all-white livestock guardian dog. A
variety of the Turkish Shepherd landrace.

Boz Shepherd

Guregh, Kurtboğan

TURKEY

Large livestock guardian and
companion dog bred by the Yörük people
in Thrace and nearby regions. A variety of
the Turkish Shepherd landrace.

Aksaray Malaklisi

Malak, Malakli Karabaş

TURKEY

Large livestock guardian dog closely
related to the Šarplaninac.

Tarsus Catalburun

Turkish Pointer

TURKEY

Medium split-nosed pointing dog also
used for police scent-detection work.

Kars Köpeği

Karadeniz, Black Sea Shepherd

TURKEY

Large livestock guardian dog closely
related to the Caucasian Ovcharka.

Dikkulak Köpeği

Çivikulak

TURKEY

Small Spitz-type watchdog
with many regional varieties. *Dikkulak*
means "erect ear."

Kopay

Turkish Chaser,
Türk İzci Köpeği Zağar

TURKEY

Medium hare-hunting scenthound bred by the
Yörük people in Thrace and nearby regions.

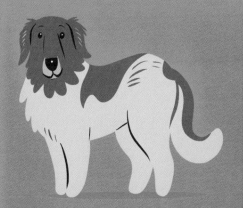

Rize Koyun Shepherd

Koyun Köpeği

TURKEY

Large livestock guardian dog that
works in the Canik Mountains.

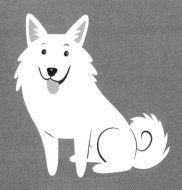

Tonya Finosu

Fino of Tonya, Kobi

TURKEY

Small Spitz-type companion
and watchdog.

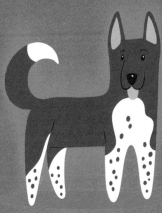

Zerdava

Kapi Köpeği, Turkish Laika

TURKEY, GEORGIA

Medium Spitz-type dog from the Trabzon
province. Used for hunting boar and marten.

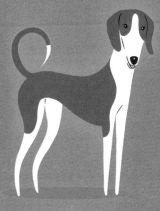

Turkish Tazi

Türk Tazısı, Anatolian Greyhound

TURKEY

Large hunting and companion sighthound
related to the Taigan and Kazakh Tazy.

Canaan Dog

Kelev K'Naani, Bedouin Camp Dog, Palestinian Village Dog

ISRAEL, THE LEVANT

In the 1930s, some of the primitive Spitz-type dogs living in the desert regions of the Levant (present-day Israel and Jordan) were developed into the Canaan Dog breed by Professor Rudolphina Menzel to work as detection dogs for the Israeli military. The Canaan Dog is the national dog of Israel. Efforts have been made to preserve the landrace's original genes and traits in the breed, despite the original population going extinct due to urbanization and habitat loss.

Saluki

Saluqi, Persian Greyhound

IRAN, FERTILE CRESCENT

Large smooth- or feather-haired sighthound with the same ancestors as the Afghan Hound. For centuries, Saluki have been bred for coursing and hunting by nomadic Bedouins and Arab royalty. In the heritage sport of falconry hunting, Saluki pups and falcons are raised together. Running up to around forty-five miles per hour, Saluki can locate and retrieve prey that has been targeted by falcons. In the 1920s, select dogs were taken to the United Kingdom and recognized as a show breed.

Qahderijani

Central Iranian Shepherd

IRAN

Large black-and-white livestock or property guardian dog from Isfahan and Chahar Mahal Bakhtiari, bred to react to strangers with barking and chasing. Sometimes Qahderijani are crossbred with Sarabi and Khorasani and trained to compete in staged dogfighting, which is a legal activity in Western and Central Asia. In general, Qahderijani dogs are dog-social, bred to live and work together as a harmonious group.

Mazandarani
Iranian Bear Dog
IRAN
Large livestock or property guardian dog
once used for bear hunting.

Sarabi
Persian Mastiff, Iranian Mastiff
IRAN
Large guard and dogfighting dog from the
northwestern cities. An endangered breed.

Khorasani
Taibadi
IRAN
Large guard and dogfighting dog
from Rzavi Khorasan Province.

Peshdar
Kurdish Mastiff, Assyrian Shepherd
IRAQ
Large livestock guardian dog. A landrace
native to the Kurdistan region.

Nagazi
Qartuli Nagazi, Georgian Shepherd
GEORGIA
Large livestock guardian landrace related
to the Tibetan Mastiff. There are two types:
Lion (mostly white) and Bear (black head).

Qurdbasar
Azerbaijan Wolfhound
AZERBAIJAN
Large-to-giant livestock guardian
or dogfighting dog related to the
Armenian Gampr.

Armenian Gampr
ARMENIA

Large livestock guardian dog bred and trained to protect sheep
and goats from wolves in the Armenian highlands. When Armenia
was colonized by the USSR, Gampr were exported and crossbred
with other breeds to create the larger Caucasian Ovcharka for military
purposes. In their homelands, Gamprs are still a pastoral landrace.
After the independence of Armenia, the Gampr was recognized
as an Armenian National Heritage dog.

Kiku (QATAR)

Olive (SAUDI ARABIA)

Leia (CENTRAL ASIA)

West Asian Village Dogs

Free-ranging and adopted companion dogs of various looks and sizes descended from the indigenous dogs of Western Asia (including the Arabian Peninsula).

Oates (AFGHANISTAN)

Zeke (ARMENIA)

Sen (AZERBAIJAN)

Nelson (KUWAIT)

Remy (ISRAEL)

Central Asian Shepherd Dog

CASD, Alabai (Turkmenistan), Tobet (Kazakhstan), Dakhmarda
(Tajikistan), Torkuz (Uzbekistan), Sredneasiatskaya Ovtcharka

TURKMENISTAN, CENTRAL ASIA

Large livestock guardian dog that has been working throughout this region for
thousands of years, protecting cattle and caravans from wild predators. During
Soviet rule, these landrace dogs were used to create the Central Asian Ovcharka
breed for military purposes. Today, there are different lineages including show
lines and dogfighting lines. In Turkmenistan, the Alabai is the national dog, and
a giant gold statue of one sits above a traffic circle in Ashgabat.

Kazakh Tazy

Kazakh Hound, Tazy
KAZAKHSTAN, CENTRAL ASIA
Large sighthound with mountain and
desert varieties. Trained to hunt with eagles.
Kazakhstan's national dog.

Taigan

Kyrgyz Taighany, Kyrgyz Sighthound
KYRGYZSTAN, RUSSIA, CHINA
Large sighthound trained to hunt
small-to-large game with eagles.

Turkmen Tazi

TURKMENISTAN
Large hunting sighthound related to Kazakh
and Kyrgyz sighthounds

Sage Kuchi

Afghan Shepherd
AFGHANISTAN
Large livestock guardian and
dogfighting dog. A variety of the
Central Asian Shepherd landrace.

Afghan Hound

Tazi

AFGHANISTAN

Large companion sighthound developed from Central Asian
hunting sighthounds (many varieties locally known as Tazi). In the
late 1800s, several Tazi were taken from Afghanistan to the United
Kingdom by the British colonial army and used to create the Afghan
Hound breed—glamorous show dogs and novelty pets selectively bred
to have longer and more lustrous hair. Afghan Hounds were almost
extinct during World War I and are a reconstructed breed. In 2005,
at Seoul University, an Afghan Hound named Snuppy was the
first dog to be cloned.

Mir (BELARUS)

Leia (CENTRAL ASIA)

Central Asian Village Dogs

Free-ranging and adopted companion dogs
descended from indigenous dogs of this region.

Väiski (RUSSIA)

Issa (CENTRAL ASIA)

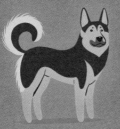

Molly (CENTRAL ASIA)

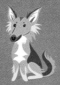

Julia (KAZAKHSTAN)

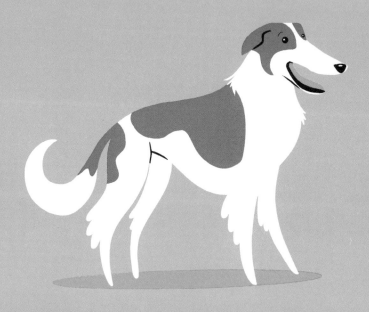

Borzoi

Russkaya Psovaya Borzaya, Russian Hunting Sighthound,
Russian Wolfhound, Zoi

RUSSIA

Large longhaired sighthound that was once popular with the
Czarist aristocracy for hunting wolves in packs. Created by crossbreeding
Saluki, thick-coated Russian sheepdogs, and at least seven types of European
sighthounds. Today's Borzoi dogs are still hunting dogs in certain parts
of Russia, Ukraine, and the United States, but they also live as indoor
companion dogs.

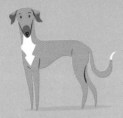

Stepnoi

Stepnaya Borzaya

RUSSIA

Large hunting sighthound
of the steppe regions.

Caucasian Ovcharka

*Kavkazskaïa Ovtcharka,
Caucasian Shepherd*

CAUCASUS, USSR

Large dogs, with Central Asian landrace
origins, created to guard Gulag camps.

East Siberian Laika

Vostotchno-Sibirskaïa Laika

RUSSIA, SIBERIA

Medium hunting Spitz in the snowy
forests, with subregional varieties.

West Siberian Laika

Zapadno-Sibirskaïa Laika

RUSSIA, SIBERIA

Medium hunting Spitz of the Mansi
and Khanty people in the Ural plains.

Yakutian Laika

Yakustkaya Laika

RUSSIA, SAKHA REPUBLIC

Medium Spitz bred by the native people
of Arctic Russia for hunting, herding, and
sled-pulling. A reconstructed breed.

Nenets Herding Laika

Olenegonka

RUSSIA, YAMALO NENETS AUTONOMOUS
OKRUG

Medium reindeer-herding Spitz
of the Nenets people.

Black Russian Terrier

Russkiy Tchiorny Terrier, Russian Black Terrier, BRT

RUSSIA, USSR

Large dog originally created by the Soviet state to be
a versatile military and working dog. Seventeen types went into
creating the breed, including Giant Schnauzers, Newfoundland
Dogs, Caucasian Ovcharkas, and Rottweilers. Today, Black Russian
Terriers are companion dogs. Despite their name, they are not
a terrier breed (see page 48).

Chukchi Sled Dog

Chukotka Sled Dog, Chukótskaya Yezdováya

RUSSIA, CHUKOTKA AUTONOMOUS OKRUG

Medium-to-large landrace Spitz bred by the Chukchi people
for seal hunting and transportation. During the nineteenth-century
Gold Rush, some dogs were imported to Alaska to pull sleds and
for racing competitions. The dogs in Alaska were renamed
Siberian Huskies by Canadians and Americans and became
a separate breed. In northern Eurasia, Chukchi Sled Dogs
are an endangered population.

Sulimov Dog

Shalaika

RUSSIA

Medium Spitz-jackal hybrid dog created
for bomb-detection work in Russian airports.
Named after Soviet biologist Klim Sulimov.

Russkiy Toy

Russian Toy, Moscow Toy Terrier

RUSSIA

Small companion dog once owned by the
Russian aristocracy. A reconstructed breed
descended from the English Toy Terrier

Russian Tsvetnaya Bolonka

RUSSIA, GERMANY

Small Bichon-type companion dog
created for apartment living. The white
variety—Franzuskaya Bolonka—became
a separate breed in the German
Democratic Republic in the 1950s.

Russian Spaniel

Rosyjski Spaniel

RUSSIA, USSR

Small companion and gun dog since
the 1950s, the result of crossing English
Cocker Spaniels and Springer Spaniels.

Samoyed

Bjelkier, Samoiedskaïa Sabaka, Sammie

RUSSIA, SIBERIA, UNITED KINGDOM

Medium white herding Spitz whose ancestors are the Nenets Herding Laika. In the late 1800s, Bjelkier dogs (as these white dogs were named) were purchased from the Nenets people by Europeans to go on various polar expeditions. The modern Samoyed are companion dogs descended from these expedition dogs and show off their skills in skijoring, sledding, and herding. Note: The term *Samoyedic* was a Russian derogatory label encompassing many local ethnic groups, including the Nenets people.

Gonchak Hound

Belorusskie Gonchaki

BELARUS

Large hunting dog related
to Polish Hounds.

Chortai

Hortaya Borzaya

UKRAINE

Large hunting sighthound.
One ancestor of the Borzoi.

South Russian Ovcharka

Yuzhnorusskaya Ovcharka

UKRAINE

Large livestock guardian dog from
the steppe regions of Crimea.

East European Shepherd

Vostochno Evropeiskaya, VEO

USSR, UKRAINE, BELARUS

Large military dog bred from
German Shepherd Dogs to be better
adapted to cold conditions.

Dogs of Chornobyl
(Russian spelling: Chernobyl)

UKRAINE

The hundreds of semi-feral dogs living in the Chornobyl Exclusion Zone
are descended from pet dogs that were left behind after their humans were evacuated
during the 1986 nuclear disaster. The pups are malnourished and in danger of attack
from rabid wolves, but they are fed and cared for by local workers in the zone and,
since 2017, have been receiving medical and trap-neuter-return procedures from
visiting nonprofit veterinarians, scientists, and volunteers with the Clean Futures Fund.
Pups receive pink or blue markings on their faces to indicate that they have been
spayed or neutered. When Russia invaded Ukraine, the dogs starved.

Moscow Metro Dog

Moscow Street Dog

RUSSIA

It has been said that there are at least five hundred mixed-breed street dogs
living in Moscow's subway stations. They have become famous for having
learned to ride the subway and commute between stations. Some dogs have
also learned to use escalators. Back in the Soviet period, street dogs were
killed or used in science experiments. One famous Moscow street dog is
Laika, who in 1957 was one of the first animals to be launched into space.

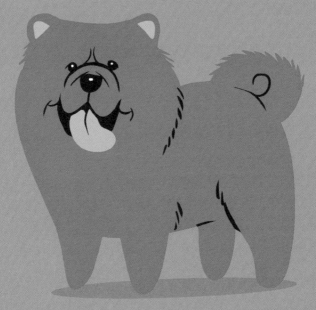

Chow Chow
Songshi Quan

CHINA, UNITED KINGDOM

Medium Spitz-type dog believed to be descended from Manchurian and Mongolian hunting and guarding dogs. In the 1800s, early Chow Chows were imported to England and displayed in the zoo as "the wild dog of China" before they were formalized into a show and companion breed. Like many native dogs of this region, Chow Chows have blue tongues, although their looks in the Fancy have changed significantly over the years.

ChuanDong Hound

Eastern Sichuan Hound

CHINA

Medium hunting dog and watchdog that resembles the dogs on ancient Han Dynasty pottery. A reconstructed breed.

ChongQing Dog

ChongQing Quan, Bamboo Tail Dog

CHINA

Small companion bulldog with a "bamboo stick" tail that became a separate breed from the ChuanDong Hound in 2018.

Chinese Red Dog

Laizhou Hong, Zhuqiao Hong

CHINA

Large family dog from Shandong Province bred to be distinctly red. Descended from German settlers' dogs.

KunMing Dog

KunMing Quan, Kunming Wolfdog

CHINA

Medium-to-large police and military dog developed in the 1950s from crossbred GSDs.

XiGou

Xiquan, Xilagou, Chinese Greyhound

CHINA, MONGOLIA

Large hunting sighthound native to northern China with many regional varieties (Shandong, Shaanxi, Hebei, Mongolia).

SongMao Dog

Songmao Gou, Chinese Native Dog

CHINA

Medium village dog from Guangdong believed to be the ancestor of the Chow Chow breed.

Pekingese

Beijing Quan, Peke

CHINA, UNITED KINGDOM

Small longhaired companion dog originally imported from China to England,
where they were redesigned and renamed from "Chinese Spaniel" to
"Pekingese" (*Peking* is the nineteenth-century name for Beijing). The legend is
that the original dogs were bred in the Imperial Court to resemble small lions
that could fit inside sleeves. One of the first Pekingeses was Queen Victoria's
Looty, and the story that Looty was stolen by the British from the Summer
Palace drove up the value of these rare imports.

Pug

Haba Gou, Dutch Bulldog, Mopshond, Mops

CHINA, NETHERLANDS

Small companion dog originally bred as a royal pet. Their local name, *Haba Gou*, means "small dog." They became Pugs (because they look like Pug monkeys, goes one theory) when taken to Europe by Dutch traders. Pugs in the early nineteenth century had longer snouts and legs before the modern (Pekingese-type) pug was designed.

Liangshan Dog

Liangshan Quan, Hushan Dog
CHINA
Medium boar-hunting scenthound
native to the Sichuan Mountain region.
Originally bred by the Yi people.

Qingchuan Hound

Qingchuan Quan
CHINA
Medium hunting dog native to the
Sichuan Mountain region. Possibly created
by crossing Liangshan Dogs with local dogs.

Xiasi Dog

Xiasi Quan
CHINA
Small-to-medium dog from
Xiasi village, bred by the Miao
people for hunting large game.

Tang Dog

Tang Gou
CHINA, HONG KONG
Medium watchdog and companion dog
indigenous to southern China. Named after
the prosperous Tang Dynasty.

Shar Pei
Chinese Fighting Dog
CHINA, HONG KONG, UNITED STATES
Medium companion dog with Chow Chow ancestry, developed from
dogfighting dogs in Guangdong. Outside communist China, the breed was
revived in Hong Kong and standardized in the United States. The American
type of "meat mouth" Shar Pei is shorter and has a wider mouth and more
wrinkles than the original Chinese "bone mouth" type.

Lhasa Apso
TIBET, INDIA
Small companion dog descended from
Tibetan landrace monastery watchdogs and
named after the Tibetan capital of Lhasa.

Tibetan Terrier
Dokhi Apso, Tsang Apso
TIBET, INDIA
Small-to-medium companion dog
developed from Tibetan landrace monastery
watchdogs. Not actually a terrier.

Shih Tzu
Xi Shi Dog
TIBET, CHINA
Small companion dog descended
from palace dogs in China. Related
to the Lhasa Apso.

Tibetan Spaniel
Sim-Khyi
TIBET, CHINA, UNITED KINGDOM
Small companion dog developed in
England from Tibetan landrace monastery
dogs. Not a hunting spaniel.

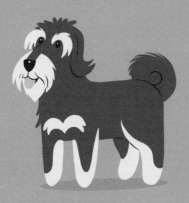

Tibetan Khyi Apso

Khyi-Apso, Bearded Tibetan Mastiff

TIBET, INDIA

Small-to-medium dog of the Tibetan plateau. A smaller, bearded variant of the Tibetan Mastiff.

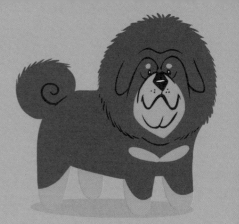

Tibetan Mastiff

Do-Khyi

TIBET, HIMALAYAS

Large livestock guardian landrace and ancestor of other mountain breeds.

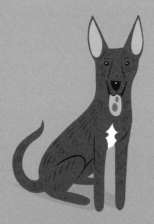

Formosan Mountain Dog

FMD, Taiwan Village Dog, Taiwan Tugou

TAIWAN

Medium primitive-type village dog— indigenous and mixed. FMDs are also adopted companion dogs.

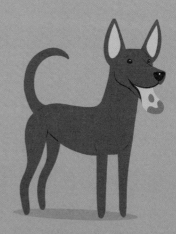

Taiwan Dog

TAIWAN

Medium companion and watchdog. A standardized breed reconstructed from various indigenous Taiwan village dogs.

Mongolian Bankhar

Hotosho, Mongolian "Four-Eyed Dog" (black-and-tan variety)

MONGOLIA, BURYATIA (RUSSIA)

Large livestock guardian dog bred by the Buryat people to fend off snow
leopards and wolves. As a landrace, they are well-adapted to high altitudes
and may be an ancestor of other livestock guardian breeds. During the
communist era, Bankhar dogs were killed, used for pelts, and almost went
extinct. Efforts are now being made to preserve the working landrace as
a part of Mongolian traditional culture.

Jindo

Jindo-gae, Korean Jindo

KOREA

Medium primitive- and Spitz-type companion dog descended
from hunting dogs and watchdogs indigenous to Jindo island. Considered
a national treasure of South Korea. There are three body types: hudu
(slender), tonggol (stockier and heavier), and gakgol (somewhere in
between). Jindo have shared ancestry with the New Guinea Singing Dog.

Donggeong-gae

Daeng Gyeon

KOREA

Medium naturally bob-tailed dog.
A South Korean heritage breed.

Sapsaree

Sapsal-gae

KOREA

Medium shaggy or shorthaired
companion dog and watchdog believed to
ward off evil spirits. A reconstructed breed
that is considered to be a national treasure.

Dosa Mastiff

Mee Kyun Dosa, Korean Mastiff

KOREA

Giant Mastiff-type companion and
show dog similar in appearance to
the Neapolitan Mastiff.

Poongsan Dog

Pungsan-gae, Pungsan Dog

KOREA

Medium Spitz-type traditional hunting dog
in the Kaema highlands. The national dog of
Democratic People's Republic of Korea
since 2014.

Akita

American Akita, Akita Matagi Inu

JAPAN, UNITED STATES

The original type of Akita—Akita Matagi Inu—were large Spitz-type dogs best known as the bear-hunting companions of the Samurai. Prior to World War II, the Akita was often crossbred with large European Mastiffs and used in dogfighting events. After the war, the surviving Akita diverged into two separate breeds with different body types: the bear-like American Akita (United States) and the foxlike Akita Inu (Japan).

Akita Inu

Japanese Akita Inu

JAPAN

Medium companion Spitz bred for
a more foxlike appearance. A national
treasure of Japan.

Hokkaido Inu

Ainu Ken

JAPAN

Medium companion Spitz developed
from the indigenous dogs of Honshu and
Hokkaido. A national treasure of Japan.

Kai Ken

Tora Inu, Kai Tiger Dog

JAPAN

Medium companion Spitz developed from
the indigenous dogs of the Kai Province
mountains. A national treasure of Japan.

Kishu Ken

Kishu Inu

JAPAN

Medium companion Spitz developed
from boar- and deer-hunting dogs from
the Kishu mountain region. A national
treasure of Japan.

Shiba Inu

Shiba Ken

JAPAN

Small Spitz-type companion dog whose ancestors were hunting dogs in the brush regions of the Chūbu mountains. In the 1920s, a patriotic program was founded to preserve "pure" indigenous dogs. Japanese village dogs were sought out and redesigned to become national assets, the Shiba Inu being one of these six national dog breeds. Before World War II, there were three regional lineages with different body sizes, colors, and markings (Minu, Sanin, Shinshu). Today's modern Shiba Inu is the combination of these various lineages and is Japan's favorite companion breed.

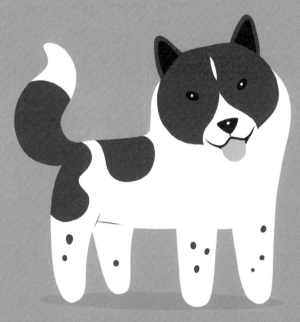

Karafuto Ken

Sakhalin Husky, Sakhalin Laika

JAPAN, RUSSIA

Medium sledding and hunting Spitz-type dog bred by the Nivkh
people of Sakhalin Island. Karafuto Ken were used on polar expeditions,
but many of the dogs did not survive because their tails had been bobbed.
Unable to cover their noses when they slept, they froze to death. (The same
fate befell the Nenets Herding Laika on their first expedition.) In the 1920s,
Nivkh people were forced into labor camps by the Soviet regime. Traditional
lifestyles were destroyed and the Karafuto Ken have been an endangered
landrace ever since.

Shikoku Ken

Kochi Ken

JAPAN

Medium Spitz-type companion dog
descended from Kochi prefecture's
indigenous dogs. A national treasure.

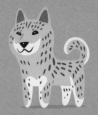

Ryūkū Inu

Okinawa Native Dog

JAPAN

Medium Spitz-type hunting
dog that is indigenous to Okinawa.
An endangered breed.

Japanese Chin

Japanese Spaniel

JAPAN, CHINA

Small companion dog that once
lived in Edo Castle.

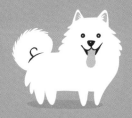

Japanese Spitz

Nihon Supittsu

JAPAN

Small Spitz-type companion dog
developed from white German Spitzes
and other imported Spitz types.

Japanese Terrier

Nihon Teria

JAPAN

Small companion dog and ratter, descended
from Fox Terriers crossed with local dogs.

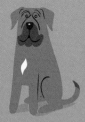

Tosa Inu

Tosa

JAPAN

Large dog bred for dogfighting.
Developed from the Shikoku Inu crossed
with European Mastiff types.

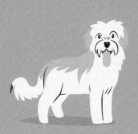

Balto (KOREA)

Mulan (KOREA)

Dani (TAIWAN)

East Asian Village Dogs

Free-ranging and adopted companion dogs
descended from indigenous dogs.

Margo (KOREA)

Miso (JAPAN, KOREA)

Frankie (CHINA)

Minnie (CHINA)

Ginger (TAIWAN)

Bully Kutta

Pakistani Mastiff

PAKISTAN, INDIA

Large dogfighting, guard, and companion dog native to the
Punjab region. Bully Kutta are possibly descended from Central Asian
Mastiff types like the Sage Kuchi, and they are considered a national
treasure. There are several crossbred lineages with variations in looks:
Aseel, Puranay, Mastiff type, Gull Dong, and Nagi.

Gull Terr

Gull Terrier

PAKISTAN, INDIA

Medium dogfighting and guard dog
from the Punjab region developed
from Bull Terriers.

Bakharwal

Kashmir Sheepdog

INDIAN SUBCONTINENT, LADAKH

Medium-to-large livestock guardian dog
bred by the Bakarwal and Gujjar nomadic
tribes. A variety of the Central Asian
Shepherd landrace.

Vikhan Sheepdog

PAKISTAN, INDIA

Medium-to-large livestock guardian dog
in the Khyber Pakhutunkhwa and Himachal
Pradesh regions.

Gaddi Kutta

Bhutia Bangara, Himalayan Mastiff

INDIA, NEPAL, BHUTAN

Large yak- and sheep-guardian
dog. A variety of the Central Asian
Shepherd landrace.

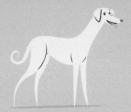

Chippiparai
INDIA

Large sighthound from Tamil Nadu, traditionally kept by royalty. Has shared ancestry with the Saluki.

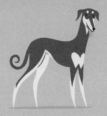

Kanni
INDIA

Large sighthound. The black-and-tan variety of the Chippiparai.

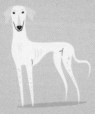

Mudhol Hound
Caravan Hound

INDIA

Large hunting sighthound and a reconstructed breed using local hounds from Karnataka. Related to the Tazi.

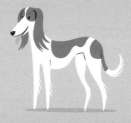

Pashmi Hound
INDIA, AFGHANISTAN

Large feathered variety of the Mudhol Hound/Tazi. Has shared ancestry with the Afghan Hound.

Rajapalayam
Polygar Hound, Indian Ghost Hound

INDIA

Large white hunting and guarding sighthound from Tamil Nadu. Now a companion and working dog in the Indian army.

Rampur Greyhound
North Indian Greyhound

INDIA

Large coursing sighthound from the Rampur region.

INDog

Indian Native Dog, Desi Dog
INDIAN SUBCONTINENT

Medium primitive-type landrace dog that has been called
the Indian Pariah Dog (*pariah* is an outdated pejorative label).
The INDogs that live in remote rural villages have been found to be
genetically distinct from modern breeds and mixes. Like all free-ranging
indigenous village dogs around the world, INDogs will go extinct with
urbanization or if they are assimilated into populations of street dogs.
(Mixed INDogs are nicknamed Indies.)

Kombai
Poligar Dog
INDIA
Medium working and companion
dog native to the Tamil Nadu region.

Indian Spitz
INDIA
Small Spitz-type companion dog believed
to be descended from the German Spitz
and well-adapted to warmer climates.

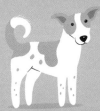

Pandikona
INDIA
Medium-to-large hunting and guarding
dog. A landrace from Pandikona village
in Andhra Pradesh.

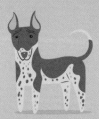

Jonangi
Kolleti Jagilam
INDIA
Small-to-medium hairless companion
and herding dog native to the Kolleru
region. They are being preserved.

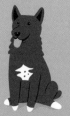

Tangkhul Hui
Haofa
INDIA
Medium hunting and companion dog
of the Tangkhul tribe in Manipur.

Sinhala Hound
*Sri Lankan Street Dog, Ceylonese
Hound*
SRI LANKA
A free-ranging street dog with various
looks—indigenous or mixed.

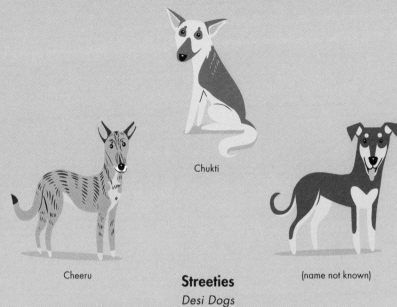

Chukti

Cheeru

(name not known)

Streeties
Desi Dogs

"Streeties" is the nickname for medium free-born, free-ranging community dogs in India with unknown, native, or mixed ancestry. Although not owned as pets, they generally have names and are bonded to local people who feed and care for them.

These are Streeties from Delhi and Bangalore.

Twinkle

Ohana

Lil Rani

Thai Bangkaew Dog

THAILAND

Medium Spitz-type companion dog developed from Bangkaew village dogs in the 1950s. They are a heritage breed of Phitsanulok province. There is a popular myth that the first dogs were descended from a local Buddhist abbot's black-and-white female dog crossed with a feral dog.

Thai Ridgeback

Thai Lang-An

THAILAND

Medium companion dog descended from ridged hunting dogs. Thailand's national dog.

Hmong Bob-Tail Dog

Chó H'Mông Cộc đuôi

VIETNAM

Medium Spitz-type working dog of the Hmong people in northern Vietnam. They are hunters, companions, and detection dogs.

Chó Lài

Lài Dog

VIETNAM

Medium longhaired or shorthaired landrace dog from the Chí Linh mountains, where there is a temple dedicated to the breed. Lài Dogs are very endangered.

Chó Bắc Hà

Bắc Hà Dog

VIETNAM

Medium heavier-coated Spitz-type watchdog of the Hmong people in the Bắc Hà mountains of Lào Cai province.

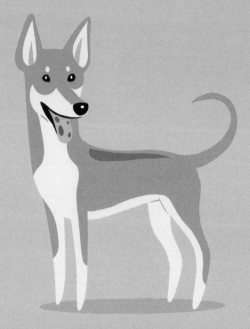

Phu Quoc Ridgeback

PQR, Chó Phú Quốc

VIETNAM

Medium primitive-type companion dog and landrace hunting dog that developed on Phú Quốc island due to isolation from other types of dogs. PQRs are the smallest of the four known breeds with dorsal ridges (the other three being Rhodesian Ridgebacks, Thai Ridgebacks, and the now-extinct Khoisan Dogs). PQRs have a variety of ridge shapes but may also be ridgeless on rare occasions. They are the national dog of Vietnam.

Asong Gubat

Philippine Forest Dog

PHILIPPINES

Medium hunting dog in the jungles of Mindanao. Petitioned to be the Philippines national dog.

Aspin

Asong Pinoy, Askal, Filipino Street Dog

THAILAND

Small-to-medium free-ranging mixed-breed street dog with diverse looks.

Singapore Special

SINGAPORE

Medium native or mixed-breed street dog and adopted companion dog.

Telomian

MALAYSIA

Medium primitive-type dog of the Indigenous people from the rainforests of Pahang. Named after the Telom River.

Anjing Kintamani

Kintamani

BALI, INDONESIA

Medium Spitz-type companion breed developed from Bali street dogs. Indonesia's national dog.

Bali Dog

Bali Street Dog, Bali Heritage Dog

BALI, INDONESIA

Medium free-ranging dog with various coat types and colors. Native to Bali.

Hanna (MALAYSIA)

Gadget (CAMBODIA)

Penelope (Aspin; PHILIPPINES)

Southeast Asian
Village Dogs

Free-ranging and adopted companion
dogs descended from indigenous dogs.

Olive (CAMBODIA)

Otis (Soi Dog; THAILAND)

Pancake (BALI, INDONESIA)

Dave (Singapore Special;
SINGAPORE)

Rojak (Singapore Special;
SINGAPORE)

New Guinea Singing Dog
New Guinea Highland Dog, NGSD

PAPUA NEW GUINEA

Medium primitive-type landrace dog living in feral populations in the highland forests. New Guinea Singing Dogs are genetically related to the Australian Dingo and indigenous Southeast Asian village dogs. They have extra-flexible bodies, and they yodel instead of bark, with a voice described as something between a wolf howling and a whale singing.

Dingo

AUSTRALIA (except TASMANIA)

This medium primitive-type dog is regarded as a protected wildlife species in some states. Dingos had a symbiotic relationship with the First Nations people and were spiritually and culturally valued within their kinship system. Since the arrival of European settlers and the spread of livestock holdings, Dingos were eradicated from Indigenous camps for killing sheep. About 50 percent of Australia's Dingo population today are mixed with European dog breeds.

Australian Cattle Dog
Blue Heeler, Red Heeler, Queensland Heeler, ACD

AUSTRALIA

Medium herding dog developed by settlers using British Collies and Dingos
to be better adapted to the hot and dry climate and terrain of rural Australia.
Cattle dogs move cattle by nipping at their heels, hence the nickname
"Heeler," and they are Blue or Red Heelers depending on their coat color.
Cattle dogs today are also scent-detection dogs and sporty companion dogs.
An Australian Cattle Dog named Bluey holds a Guinness World Record for
oldest living dog at twenty-nine and a half years old. Bluey is also the titular
character in a popular animated kids' TV show.

Koolie

German Collie

AUSTRALIA

Medium working-type dog
developed by German settlers.

Stumpy Tail Cattle Dog

Stumpy

AUSTRALIA

Medium bob-tailed cattle-herding dog.
A different, taller, and leaner breed
from the Australian Cattle Dog.

Murray River Retriever

Murray

AUSTRALIA

Medium duck-retrieving, search-and-rescue,
and assistance dog.

Australian Kelpie

AUSTRALIA

Medium sheep-herding dog from
rural Victoria known for walking on
the backs of sheep.

Bull Arab

AUSTRALIA

Large working type of feral hog–hunting
dog developed from crossing Bull Terriers,
Mastiffs, Pointers, and Greyhounds.

Smithfield

Smithfield Collie

AUSTRALIA

Medium-to-large sheep-herding
dog from Tasmania.

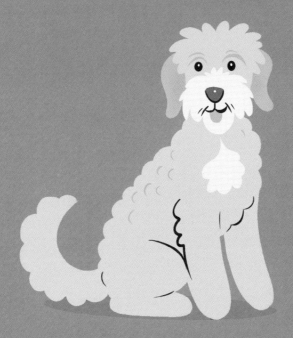

Australian Cobberdog

Labradoodle

AUSTRALIA

Medium assistance and therapy dog created by crossbreeding Labrador
Retrievers, Poodles, Cocker Spaniels, and a few other breeds to have
"hypoallergenic" coats. Cobberdogs are working dogs with breed standards
and not to be confused with Labradoodles (and other Doodles/Poodle mixes)
that are crossbred companion dogs. According to science, there are low-
shedding coats, but there is no such thing as a hypoallergenic coat
as allergens are found in dogs' dander and saliva.

Australian Staghound
Kangaroo Dog
AUSTRALIA
Large-to-giant Lurcher type whose
ancestors were used by settlers and First
Nation peoples to hunt kangaroos.

Australian Terrier
AUSTRALIA
Small hunting terrier developed
from British Terriers. Considered
Australia's first purebred dog.

Silky Terrier
Australian Silky Terrier
AUSTRALIA
Small companion terrier native to
Sydney. The result of crossing the Australian
Terrier with the Yorkshire Terrier.

Russell Terrier
ENGLAND, AUSTRALIA
Small original variant of the British
Jack Russell Terrier that was standardized
in Australia, with shorter legs.

Tenterfield Terrier
AUSTRALIA
Small companion dog named after
entertainer Peter Allen's grandfather,
the "Tenterfield Saddler."

New Zealand Heading Dog
NEW ZEALAND
Medium herding dog developed from
Border Collies, with shorter coats.

Huntaway
New Zealand Huntaway, New Zealand Sheepdog, Huntie

NEW ZEALAND

Large sheep-herding dog developed to work in steep rough terrain
in the New Zealand high country. Huntaways are bred for their working
abilities—e.g., their loud, persistent, booming bark to move sheep—and are
not recommended for a pet lifestyle. They also have a variety of looks and
may be shorthaired, longhaired, or wirehaired. In 2013, the New Zealand
Kennel club recognized the Huntaway as the first and only indigenous
breed from New Zealand.

Camp Dogs

The dogs that live in Indigenous Australian communities are called camp dogs. They have a variety of looks. To outsiders, camp dogs often get mistaken for strays, but they are cared for, even though they live outdoors and are free to roam with their friends. Camp dogs also participate in sports and games at local events and follow their owners everywhere. Their well-being is dependent on there being enough food and accessible health resources in their communities.

These dogs are from Manyallaluk, Wugularr, and Barunga in central Arnhem Land.

Canadian Inuit Dog

Qimmiq, Kalaallit Qimmiat, Canadian Eskimo Dog, Greenland Dog

NUNAVUT, GREENLAND, CANADA

Medium Spitz-type dog that was traditionally bred by the Inuit to be their mode
of transport and hunting companion. Having been replaced by modern snowmobiles
and firearms, Inuit Dogs, the official dog of the Nunavut territory, are now more
involved in sport hunting and ecotourism. Although the Canadian Eskimo/Inuit Dog
and Greenland Dog are recognized as two separate breeds by some kennel clubs,
they share the same origins and genetics.

Newfoundland
Newf

CANADA, NEWFOUNDLAND, UNITED KINGDOM

Large companion dog that was once the fishermen's dog of
pre-Canada Newfoundland. Newfs are known for their water-rescue
work, a job they are well-adapted to with their thick waterproof coats
and webbed paws. They have the same ancestor (the extinct St. John's
Water Dog landrace) as Labrador Retrievers and other British
retriever breeds.

Landseer
Landseer Newfoundland
NEWFOUNDLAND, CANADA
The black-and-white variety of
Newfoundlands. A separate breed
in Europe, named after the famous dog
painter Edwin Landseer.

Cape Shore Water Dog
CANADA
Medium type of water dog descended
from the extinct St. John's Water Dog.

Nova Scotia Duck Tolling
Retriever
Toller
CANADA
Medium waterfowl-luring
("tolling") and retrieving dog.

Saint Pierre
Labernese
CANADA
Medium-to-large guide dog (not a pet)
created from second-generation Bernese
Mountain Dog and Labrador crosses.

Alaskan Malamute

UNITED STATES

Large companion dog developed from the working sled dogs of the
Malimiut Iñupiaq people. Malamutes are considered a basal breed, as their
geographical and cultural isolation has led to relatively little genetic mixing
with modern European breeds. They are related to the Siberian Husky and
Canadian Inuit Dog, and they are Alaska's state dog.

Siberian Husky
Sibe
UNITED STATES, SIBERIA
Medium companion dog developed in Alaska from Chukchi Sled Dogs. Became famous for delivering medication to the isolated community of Nome in 1925.

Chinook
Nook
UNITED STATES
Medium working companion dog descended from expedition sled dogs. A rare breed and New Hampshire's state dog.

Alaskan Husky
UNITED STATES
Medium mixed-breed sled dog bred exclusively for competitive racing, including the annual 1,049-mile Iditarod sled dog race.

Alaskan Klee Kai
AKK
UNITED STATES
Small companion dog that looks like a small Husky. *Klee Kai* means "little dog" in Athabaskan. There are three size varieties: toy, miniature, and standard.

Carolina Dog

Yaller Dog, American Dingo, North American Native Dog

UNITED STATES

Medium primitive-type companion dog that is descended from
feral dogs in the swampy areas of South Carolina. In the 1970s, these
dogs were discovered by Dr. I. Lehr Brisbin to be living in a very remote site
(with nuclear waste materials) where they had had no contact with humans
or other dogs for a very long time. They were also found to be genetically
similar to East Asian village dogs and Australian Dingos. There is a theory
that the ancestors of Carolina Dogs migrated from Asia over the Bering
Land Bridge around twenty thousand years ago.

Rat Terrier

Ratting Terrier, Rattie

UNITED STATES

Small sporty companion dog whose Feist ancestors were
working types bred by farmers and hunters to kill rodents. In the 1950s,
many Rat Terriers lost their jobs when people switched to poison to kill
rats instead. Other lineages of Rat Terriers include the shorter Teddy
Roosevelt Terrier and the American Hairless Terrier.

Toy Fox Terrier
UNITED STATES
Small companion dog, originally
a variety of the Smooth Fox Terrier. One
of only a few American toy breeds.

Chinese Crested
UNITED STATES
Small companion dog of uncertain origin,
genetically related to the Xolo from Mexico
and first bred in the United States by news
reporter Ida Garrett. The coated variety
is called Powderpuff.

American Hairless Terrier
UNITED STATES
Small companion dog developed from
hairless Rat Terriers as a separate breed.
There is also a coated variety.

Boston Terrier
Bostie, BT
UNITED STATES
Small companion dog and Massachusetts's
state dog. Nicknamed "The American
Gentleman" for their black-and-white
tuxedo coats.

American Pit Bull Terrier

APBT, Pit Bull, Pittie, Pibble

UNITED STATES

Medium working and companion dog descended from catch dogs and pit-fighting dogs. American Pit Bull Terrier is the breed registered with the UKC. The American Staffordshire Terrier (that looks the same) is the AKC breed. The Pit Bull umbrella label is often used to identify all similar-looking dogs, including mixed-breed dogs. Due to media stereotypes and a widespread misunderstanding of dog behavior, Pit Bulls have been the target of discriminatory laws based on how they look.

American Staffordshire Terrier
AmStaff
UNITED STATES
Medium companion dog. An AKC breed
with the same ancestors as the American
Pit Bull Terrier.

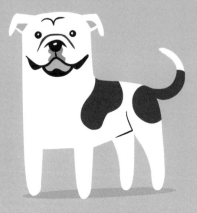

American Bulldog
UNITED STATES
Medium-to-large dog descended from
bullbaiting and catch dogs. Used for hunting
feral hogs in the South.

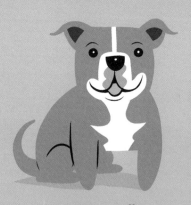

American Bully
UNITED STATES
Companion dog with four size varieties
(S, M, L, XL), designed to have blocky heads
and heavy bone structure. Recently, XL Bullies
(at a height of 20 inches or more) were
banned in the United Kingdom.

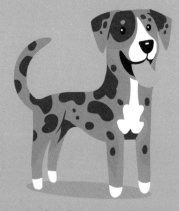

Catahoula Leopard Dog
Catahoula Cur, Catahoula Hog Dog
UNITED STATES
Medium-to-large feral hog–hunting and
cattle-herding dog. Louisiana's state dog.

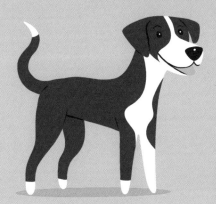

Mountain Cur
UNITED STATES

Medium working dog and a reconstructed breed developed from the hunting dogs of Appalachian Mountain settlers.

Black Mouth Cur
Southern Cur
UNITED STATES

Small-to-medium working and hunting dog in the Southern United States.

Blue Lacy
Lacy Hog Dog, Lacy Dog
UNITED STATES

Medium ranch dog for cattle herding and hog hunting. Texas's state dog.

American Foxhound
AFH
UNITED STATES

Medium fox-hunting dog developed by George Washington. Virginia's state dog.

Bluetick Coonhound

Bluetick

UNITED STATES

Large scenthound and one of several American
raccoon-treeing breeds. (The raccoon is where the name *Coonhound*
comes from.) Blueticks originated in Louisiana and were developed using
Foxhounds and Grand Bleu De Gascogne dogs. In 2019, the Bluetick
Coonhound became Tennessee's state dog.

Black and Tan Coonhound
American Black and Tan Coonhound
UNITED STATES
Medium treeing scenthound with
some Bloodhound ancestry.

American English Coonhound
Redtick Coonhound
UNITED STATES
Medium-to-large treeing and foxhunting
scenthound developed in Virgina.

Plott Hound
Plott
UNITED STATES
Medium scenthound bred by the Plott
family using German hounds. North
Carolina's state dog.

Redbone Coonhound
Redbone
UNITED STATES
Medium-to-large treeing
scenthound named after Tennessee
breeder Peter Redbone.

Treeing Walker Coonhound
UNITED STATES
Medium-to-large treeing scenthound from
Kentucky that used to be the same breed
as the American English Coonhound.

American Leopard Hound
Leopard Cur
UNITED STATES
Medium-to-large treeing scenthound
descended from Spanish and Mexican
dogs and local curs.

Boykin Spaniel
UNITED STATES

Small waterfowl-retrieving dog developed by Whit Boykin. South Carolina's state dog. September 1st is Boykin Spaniel Day.

American Cocker Spaniel
Cocker
UNITED STATES

Small show and sporting companion dog bred to different standards from English Cocker Spaniels.

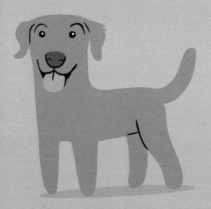

Chesapeake Bay Retriever
Chessie
UNITED STATES

Medium gun dog and waterfowl retriever. Maryland's state dog.

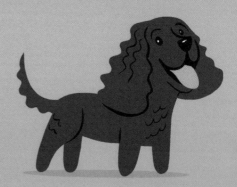

American Water Spaniel
AWS
UNITED STATES

Small curly-coated waterfowl retriever. Wisconsin's state dog.

Australian Shepherd

Aussie

UNITED STATES

Medium working and sports companion dog originally developed by
Californian ranchers and rodeos using Spanish and Australian sheepdogs, with
some Collie ancestry. Despite their name, they are an American breed! Working
Aussies generally have a loose-eyed (non-staring/stalking), upright herding style and
they move from side to side ("wear") to gather and move sheep or cattle forward.
There is a similar-looking breed with shared ancestry called the English Shepherd
(UKC) and an offshoot smaller breed, the Miniature American Shepherd.

American Indian Dog
UNITED STATES, CANADA, MEXICO
Medium dog bred by Kim La Flamme to look like pre-European dogs. Not to be confused with the North American Indian Dog (Continental Kennel Club).

Shiloh Shepherd
UNITED STATES
Medium companion dog that looks like a larger German Shepherd Dog. Developed in the 1990s by Tina Barber.

McNab Dog
McNab Shepherd
UNITED STATES
Medium herding dog from Northern California named after Alexander McNab, their creator.

American Staghound
Longdog, American Lurcher
UNITED STATES
Large-to-giant Lurcher-type of prairie hunting dog of small and large game.

Silken Windhound
Silken
UNITED STATES
Medium longhaired sports and companion sighthound developed in Texas from Borzois and Lurchers.

Silken Windsprite
Longhaired Whippet
UNITED STATES
Small longhaired sports and companion sighthound developed from Whippets.

Chihuahua

Chihuahueño

MEXICO

One of the smallest companion and show breeds, and a descendant of the extinct (Aztec) Techichi dog, found to have some pre-Columbian DNA. There are two varieties—"apple head" (domed skull) and "deer head" (longer muzzle)—with the latter type not accepted in competition. The various size labels (teacup, miniature, pocket) have often been unscrupulously used by sellers to fetch higher prices for smaller Chihuahuas.

Reservation Dogs
Rez Dogs

Free-ranging dogs that live on the hundreds of Native American reservations in North America. In Native American cultures, dogs are generally not kept locked-up indoors. The thousands of dogs living on reservations—with a variety of looks and mixed-breed ancestries—are seen as autonomous beings and free to roam outside. They are often mislabeled as strays or feral dogs by outsiders, but many are owned community dogs (see page 61) that are loved and cared for by their humans and attended to by volunteer-driven mobile veterinary clinics.

Dogs of GOD'S LAKE, MANITOBA

Some of the dogs on reservations are also dogs that are the result of abandonment and unchecked breeding over many years. There are rescue groups who are working hard to educate people about how smart rez dogs are; providing free and low-cost spay, neuter, and vaccine clinics; and finding adoptive homes for them.

Dogs from UNDERDOG RESCUE, Four Corners Native
American Reservations

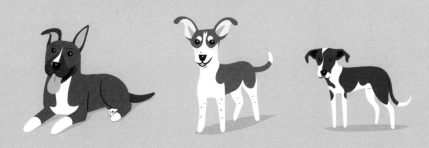

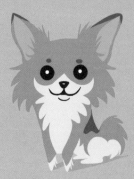

Longhaired Chihuahua

MEXICO, UNITED STATES

The longhaired variety of Chihuahua,
which is considered a separate breed
in the United Kingdom.

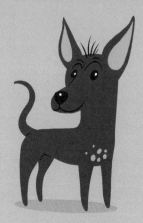

Xoloitzcuintle

Xolo, Mexican Hairless Dog

MEXICO

Small-to-medium companion
dog descended from indigenous dogs
that have a dominant hairless gene.
A cultural symbol of Mexico City.

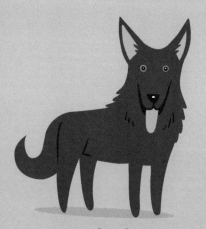

Calupoh

Mexican Wolfdog

MEXICO

Large companion dog. A reconstruction of
a pre-Hispanic type of wolf-dog hybrid.

Perro Callejero

Mexican Street Dog

MEXICO

Small-to-medium mixed breed
street dog with diverse looks.

Havanese

Bichon Havanais

CUBA, UNITED STATES

Small companion dog and Cuba's national dog, believed to have descended from the Bichon-type dogs of Tenerife settlers. During the Cuban Revolution, a few dogs traveled with immigrants to the United States and became the Havanese breed. The offshoot Havana Silk Dog lineage is a reconstruction of the pre-eighteenth-century "original" Cuban type of Havanese.

Dogo Guatemalteco

Guatemalan Dogo

GUATEMALA

Medium Mastiff-type companion
and guard dog derived from Bull Terrier
crosses. Guatemala's national dog.

Sato

Puerto Rican Street Dog

PUERTO RICO, UNITED STATES

Small-to-medium mixed-breed
street dog. Many are being adopted
as companion dogs.

Chucho Aguacatero

El Salvadoran Street Dog

EL SALVADOR

Small-to-medium mixed-breed street dog with
diverse looks, nicknamed "avocado dog"
because they will eat anything they can find.

Potcake

Pothound

CARIBBEAN ISLANDS

Small-to-medium mixed-breed dog that has
diverse looks. Named after the congealed
rice at the bottom of the family cooking pot.

Zaguate

COSTA RICA, NICARAGUA

Small-to-medium mixed-breed dog that
has diverse looks. Their name comes from
zahuatl, the Nahuatl word for "mange," as
street dogs often suffer from diseases.

Aguacatero

Honduran Street Dog

HONDURAS

Small-to-medium mixed-breed street
dog that has diverse looks.

Peruvian Hairless Dog

Peruvian Inca Orchid/PIO (AKC), Viringo, Perro Sin Pelo del Perú

PERU

Small-to-medium primitive-type companion dog whose ancestors are an indigenous landrace, kept as pets, from pre-Incan times. Peruvian Hairless Dogs come in three size varieties; have chocolate-brown, gray, copper, or mottled skin colors; and may also be coated. The favored hairless variety is extra sensitive to extreme temperatures and skin issues, and is also born with missing teeth. Peruvian Hairless Dogs were developed into a breed in the 1980s and have been the national dog of Peru since 2011.

Colombian Fino Hound
Sabueso Fino Colombiano
COLOMBIA
Medium-to-large scenthound developed
from colonial Iberian hunting hounds.

Mucuchies
Venezuelan Sheepdog
VENEZUELA
Large Andean Highlands livestock guardian dog
once owned by Simón Bolivar. A reconstructed
breed and Venezuela's national dog.

Dogue Brasileiro
Bull Boxer
BRAZIL
Medium guard dog developed
from Bull Terrier crosses.

Buldogue Campeiro
Campeiro Bulldog
BRAZIL
Medium cattle and companion dog.
A reconstructed breed.

Fila Brasileiro

Brazilian Mastiff, Cao de Fila

BRAZIL

Large rural catch and companion dog descended from colonial Iberian dogs. Has variations in looks and sizes due to at least three different club standards.

Gaucho Sheepdog

Ovelheiro Gaucho, Brazilian Sheepdog

BRAZIL

Medium-to-large sheepdog from the Pampas region, possibly descended from Collies.

Rastreador Brasileiro

Urrador, Brazilian Tracker

BRAZIL

Medium-to-large scenthound once used to track jaguars. A breed that is being reconstructed after going extinct.

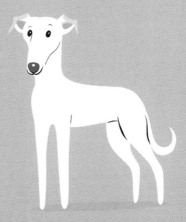

Pampas Deerhound

Veadeiro Pampeano

BRAZIL

Medium deer-tracking and catching dog of the Pampas region.

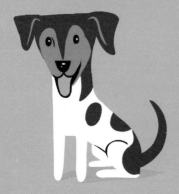

Brazilian Terrier
Terrier Brasileiro, Fox Paulistinha
BRAZIL
Small farm and companion dog developed from European terriers and local dogs.

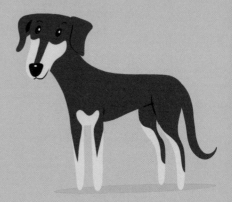

Viralata
Brazilian Street Dog
BRAZIL, DOMINICAN REPUBLIC
Small-to-medium mixed-breed street dog with diverse looks. Their name means "boat turner"—which comes from their habit of turning over garbage cans in search of food.

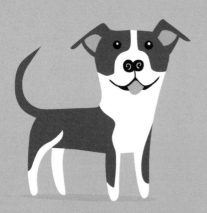

Andean Tiger Hound
BOLIVIA
Medium split-nose dog that was discovered in the Amazon in the 2000s. Possibly related to the Pachón Navarro.

Bolivian Khala
Quecha, Kala
BOLIVIA
Medium-to-large dog from the same landrace as the Peruvian Hairless Dog.

Quiltro

Chilean Street Dog, Mestizo

CHILE, BOLIVIA

In Latin America, free-ranging mutts have different names depending on region and local colloquialisms, and these names may be used in derogatory or endearing ways depending on context. *Quiltro* is the Chilean name for a mixed-breed street dog. One famous quiltro is Negro Matapacos, a black dog who frequently appeared on the front lines of student protests barking at the police in Santiago in 2011. Negro Matapacos—portrayed wearing a red bandana around his neck—is now a symbol of justice and resistance against police brutality.

In Paraguay and Equador, a street dog is a delmer; in Peru, they are chandas or chuscos; in Argentina, they are cuzcos, and these are just a few of the other names.

Patagonian Sheepdog
Ovejero Magallánico
CHILE
Medium sheepdog of southern Patagonia believed to be descended from the now-extinct Old Welsh Grey Sheepdog.

Chilean Terrier
Terrier Chileno
CHILE
Small rural and urban companion dog developed by crossing Fox Terriers with Andalusian Wine-Cellar Rat-Hunting Dogs.

Cimarrón Uruguayo
URUGUAY
Large guard dog bred from abandoned Iberian colonial dogs that had become feral. The mascot of the Uruguay national army.

Argentine Pila
El Perro Pila
ARGENTINA
Small-to-medium dog from the same landrace as the Peruvian and Bolivian hairless breeds.

Dogo Argentino
Argentinian Mastiff
ARGENTINA
Medium-to-large Mastiff and a reconstruction of the extinct Old Cordoba Fighting Dog. Illegal in some countries.

Patagonian Greyhound
Galgo Barbucho, Barbucho Criollo
ARGENTINA
Large rough-coated Lurcher and hunting dog bred for the Patagonian climate and terrain.

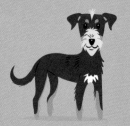

Ozzie (DOMINICAN REPUBLIC)

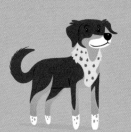

Cheto (MEXICO)

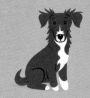

Spock (USA)

American Village Dogs

These are descendants of European dogs of various sizes that were imported to the Americas during the Colonial era. Over the generations, they have mixed with local dogs and have a wide range of looks.

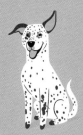

Ellie (MEXICO)

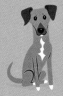

Ruby Roo (Cunucu; ARUBA)

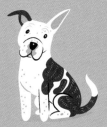

Kassi (Sato; PUERTO RICO)

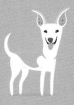

Pepita (Sato; PUERTO RICO)

Acknowledgments

There was a time when I couldn't guess a dog's breed if I met one on the street or saw one in a photo. Even after years of drawing dogs professionally, I could name only a handful of breeds. I went from knowing very little about breeds to learning that there is a lot to know!

Dogs of the World is the longest, most fascinating, and all-consuming project I have ever worked on, and I could not have done this alone. I am grateful for the conversations, encouragement, and generosity I have received from all these individuals from different areas of dog study and dog care, as well as dog-loving friends, who let me ask all kinds of questions, referred me to resources, gave me permission to draw their dogs, and/or offered feedback on early drafts.

Thank you from the bottom of my heart to Chris Nelson, Dr. Jessica Perry Hekman, Sara Reusche, Nickala Squire, Karen Hinchy, Dr. Mikel Delgado, Tracey McLennan, Dr. Kathryn Lord, Dr. Mia Cobb, Mara Velez, Dr. Adam Boyko, Craig Koshyk, Rajashree Khalap, Steffi Nierhoff, Edith Gallant, Dan Khanh Tran, Kira Hoang, Faraz Shojaei, Kurosh Nazari, Ezri Silverberg, Emily Strong, Allie Bender, Dr. Shelly Volsche, Dr. Susan Friedman, Austin Hoffman, Giovanni Padrone, Scottie Westfall, Laura Holder and Josephine Locke (Conservation Dogs Collective), John Reilly, Nick Benger, Melissa McCue-McGrath, Dr. Eduardo Fernandez, Dawn Bender, Natalia Martinez, Laura Osanitch, Linda Beckelman, Dr. Susan Hazel, Dr. Zazie Todd, my agent Lilly Ghahremani, and my husband, Nathan Long, who once said to me: "I thought dog breeds were naturally occurring."

Many dog lovers sent me photos to draw from. Thank you to to Emma-Jean Weinstein at Embark for connecting me with my village dog models and their humans. Thank you also to Valli Fraser-Celin, Rachel Forday, Kevin Beh, Evie Ryland, Stephanie Wolf, Sindhoor Pangal, Aditi Joshi, Dr. Melissa Beyer (Rural Area Veterinary Services), Ethel Morgan (Wakpá Wašté Animal Shelter and Clinic), Kaylene Doust (Roper Gulf Regional Rescue), Underdog Animal Rescue and Rehab, and Dogs of Chornobyl (Clean Futures Fund) for the honor of drawing the dogs in their care.

Thank you to my editor and fellow dog lover, Julie Bennett, for making order out of my chaos, and much respect to book designer Isabelle Gioffredi for creating something beautiful and cohesive out of a jumble of image files. I am very grateful to the enthusiastic team at Ten Speed Press.

There are too many dog breed–related books, articles, podcasts, and websites to list here. For links to references and recommended resources, as well as material that did not make it into this book due to space limitations, please visit www.doggiedrawings.net.

The dog illustrations in the book's endpapers feature pups belonging to friends and clients, and include my dearly departed Boston Terrier, Boogie.

Index

Published in the United States by Ten Speed
Press, an imprint of the Crown Publishing
Group, a division of Penguin Random
House LLC, New York.
TenSpeed.com

Ten Speed Press and the Ten Speed Press
colophon are registered trademarks of
Penguin Random House LLC.

Approximately half of the illustrations
included here were originally self-published,
sometimes in different forms, between 2014
and 2018 by the author.

Typeface: Linotypes's Futura

Library of Congress Cataloging-in-Publication Data
Names: Chin, Lili author illustrator
Title: Dogs of the world : a gallery of 600+ pups
from purebreds to mutts / written and illustrated
by Lili Chin.
Identifiers: LCCN 2024029224 (print) | LCCN
2024029225 (ebook) | ISBN 9781984862006
hardcover | ISBN 9781984862013 ebook
Subjects: LCSH: Dogs—Pictorial works
Classification: LCC SF430 .C474 2025 (print) |
LCC SF430 (ebook) | DDC 636.70022/2—dc23/
eng/20240827
LC record available at https://lccn.loc.gov/
2024029224
LC ebook record available at https://lccn.loc
.gov/2024029225

Hardcover ISBN: 978-1-9848-6200-6
eBook ISBN: 978-1-9848-6201-3

Printed in Malaysia

Editor: Julie Bennett | Production editor:
Sohayla Farman
Designer: Isabelle Gioffredi | Production
designers: Claudia Sanchez and Faith Hague
Production manager: Jane Chinn
Copyeditor: Bridget Sweet | Proofreaders:
Kate Bolen and Alisa Garrison | Indexer:
Ken DellaPenta
Publicist: Felix Cruz | Marketer: Joey Lozada

10 9 8 7 6 5 4 3 2 1

First Edition

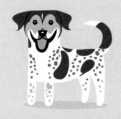
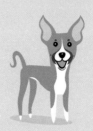
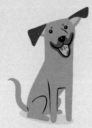
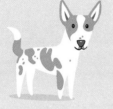
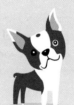
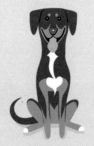
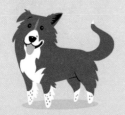